A–Z

OF

AYLESBURY

PLACES - PEOPLE - HISTORY

Yvonne Moxley

AMBERLEY

First published 2019

Amberley Publishing
The Hill, Stroud, Gloucestershire, GL5 4EP
www.amberley-books.com

Copyright © Yvonne Moxley, 2019

The right of Yvonne Moxley to be identified as
the Author of this work has been asserted in
accordance with the Copyrights, Designs and
Patents Act 1988.

ISBN 978 1 4456 9185 5 (print)
ISBN 978 1 4456 9186 2 (ebook)

British Library Cataloguing in Publication Data.
A catalogue record for this book is available
from the British Library.

Typesetting by Aura Technology and Software
Services, India. Printed in Great Britain.

Contents

Introduction

Aylesbury will always be associated with its ducks but this thriving market town has even more to offer than the history of its ducklings. The Romans, Anglo-Saxons, Danes, and all other conquering invaders have all left their mark on the town – in its cobbled streets, quirky squares, and in its famous and infamous residents.

It first appeared in the Doomsday Book in 1086 under the heading of 'Land of the King'. It was considered an important trading centre with a weekly market together with a sizeable, rich agricultural area and an abundance of sheep, thereby making it responsible for paying the enormous fees of £56 a year as well as £10 from its tolls.

The oldest sections of Aylesbury are around Market Square, St Mary's Church and Kingsbury; however, much of its personality comes from the people who made this town a special place in which to visit, live and work. From Cromwell to David Bowie, all left their mark on the places, people and history, including, of course, its prized white ducks!

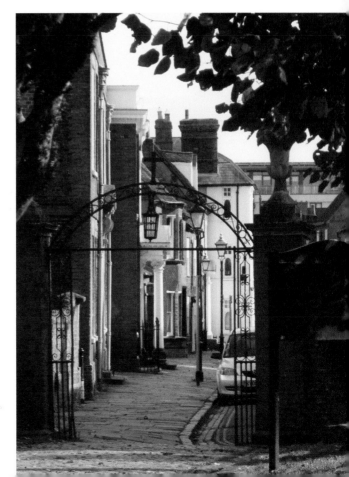

Looking through St Mary's Church gates to Church Street.

Akeman Street – Courtesy of the Romans

The busy A41 road running through Aylesbury was once a rough dirt track leading to a hill fort, probably made as far back as 650 BC during the Iron Age. The Romans, famed for their straight roads, converted the track into a paved roadway running 78 miles linking Watling Street in Verulamium to the town of Corinium – now St Albans and Cirencester, respectively.

Akeman Street was used to transport Roman troops and their equipment from one place to another and later proved to be greatly advantageous for increasing trade in the area. These were relatively peaceful times with the Romans obviously prepared to stay judging by the Roman villa remains dotted along the highway.

Saxon soldiers were left in charge of the thoroughfare when the Romans left, and remains of a British and Roman settlement from the first and second century have recently been found in the centre of the town.

Landscaped roundabout on the A41, once an old Roman road.

Almshouses – Through the Kindness of Thomas Hickman

Over the centuries Aylesbury had grown into a busy agricultural market town but by the middle of the seventeenth century much of the population consisted of an unacceptably large number of poor people. The figures were confirmed by the Hearth Tax of 1662 in the reign of Charles II.

Twice a year inhabitants with fires, hearths and stoves paid one shilling for each item. The number of those exempt was between 60 and 70 per cent.

Thomas Hickman, a comparatively wealthy resident, had spent much of his life helping the poor. In his will of 1698, he left five cottages to be used as almshouses for the elderly and for those in need, hardship or distress. However, he stipulated that his family take precedence over other people in the parish.

Initially the properties were well cared for under the guidance of his cousin, Robert, but in later years the houses fell into disrepair with accounts and records either lost or not kept. Future members of the family were given the name Hickman, even as a middle name, so as to claim their entitlement to an almshouse.

In 1858 Mary Hickman White shared a cottage with her husband, who was not a local parishioner, and her illegitimate son. This was frowned upon by the charity commissioners who amended the rules to ensure that occupants were 'being of good character and regular attendants of public worship'.

Under these stricter regulations the five almshouses were renovated, giving each cottage a living room, scullery, tiny pantry and two bedrooms, with one outside toilet to be shared amongst all the occupants.

By 1955 only one cottage was occupied by a Hickman family member, the remaining four accommodated by local people. The charity still provides help with housing and hardship grants and is Aylesbury's first and only independent, privately owned charity.

Thomas Hickman's picturesque almshouses, Church Street.

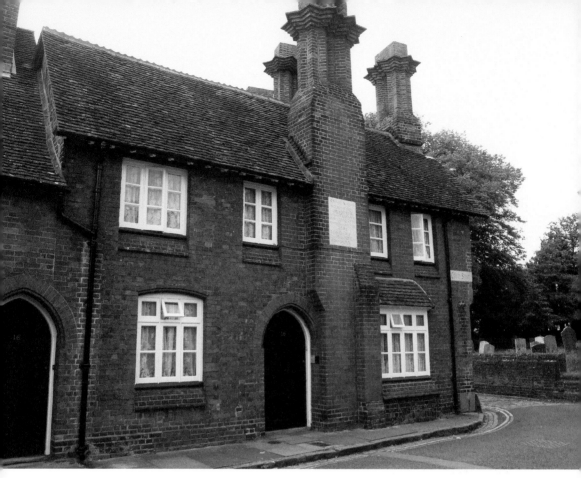

Cousin Robert Hickman's house, Church Street.

Aylesbury Ducklings – Possibly the Best in the Duck World

No one seems to say the word Aylesbury without following it with 'duck'. These famous birds, distinguishable by their white feathers, pale pink beaks (developed from eating the local grit) and their orange feet, are today bred by only one authorised breeder, Richard Waller, whose family has been in the business since the mid-1770s.

Originally the ducks were bred by families in Duck End, now renamed Mill Way, and the fertilized eggs would be delivered to the townsfolk where the ducklings were given the privilege of being reared inside the breeders' cottages. Rows of hay-filled wooden boxes lined the walls of the living areas and sometimes even the bedrooms.

Richard Waller tells that 'the romantic story of ducklings walking forty miles from Aylesbury to the London meat market with their feet covered in cold tar liquid and sawdust for protection, is not true'. Geese were transported in this way; however, ducks are water birds and their legs could not sustain a long-distance walk. The ducks would have been taken by horse and cart until the arrival of the canal and the railway.

Aylesbury ducklings fatten up quickly and together with their excellent taste their popularity was partly due to thousands of ducks being transported to the capital city where the meat found its way to all the top hotels and restaurants. A quarter of a million ducks per year were produced in their heyday.

By the start of the First World War the cost of duck food had quadrupled, there was competition from other duck breeds, and the demand for luxury foods plummeted. After the war there were approximately twenty families making their living from Aylesbury ducks but now only Richard Waller continues the breeding of the true Aylesbury ducklings. Unfortunately, due to current strict European Union regulations, Richard is unable to sell to the London restaurants, giving him only two local establishments with which to trade.

At his farm, almost hidden from the surrounding housing estate, Richard hatches the ducklings in incubators and after a few weeks of careful husbandry they are kept outside in large fenced runs, foraging on grass and insects as well as being fed high protein pellets.

Mrs Beeton's best-selling *Book of Household Management*, published in 1861, states:

> The white Aylesbury Duck is, and deservedly, a universal favourite. Its snowy plumage and comfortable comportment, makes it a credit to the poultry-yard, while its broad and deep breast, and its ample back, convey the assurance that your satisfaction will not cease at its death.

A rather sad, inevitable, but fitting tribute.

Below left: Two-week-old and one-week-old Aylesbury ducklings.

Below right: Richard Waller on his farm with an adult Aylesbury duckling.

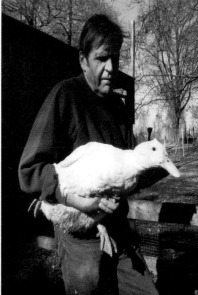

Barker, Ronnie – Legendary Comedian

A bronze statue of the much-loved comic Ronnie Barker sits on a stone bench with his ankles and arms crossed in typical *Porridge* clothing, where you can find him looking up at the new Waterside Theatre. The life-sized statue was modelled by Martin Jennings, who also sculpted the statue of the poet Sir John Betjeman at St Pancras station in London.

The unveiling of Ronnie Barker (aka Norman Stanley Fletcher) and other well-known characters took place in 2010 attended by his wife, Joy, who was accompanied by Ronnie's two fellow actors, Ronnie Corbett and Sir David Jason.

Ronnie Barker was born in Bedford in 1929 and joined the Aylesbury Repertory Company, beginning his acting career here in 1948. He became a popular radio performer in the 1960s and also appeared in a number of productions in the West End, but it was the television sketch show *The Two Ronnies* with Ronnie Corbett, running for twelve series over sixteen years, where he really made his mark on the comedy scene.

He won four television Bafta awards and was presented with an OBE in 1978. After a long career he died in 2005 aged seventy-six, but his sketches and classic comedy series still continue to entertain.

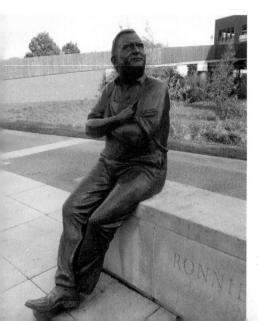

Ronnie Barker statue beside the Waterside Theatre.

Bates, Dr Benjamin – An Unfortunate Doctor

There is only a vague early history of the life of Dr Bates. It is said he was born around 1736 and that he studied medicine at Edinburgh University; however, the university has no record of him being there.

What can be confirmed is that he bought a house in Rickmans Hill and was a general practitioner in the town. Along with his colleague John Wilkes MP he was a member of the Hell Fire Club, notorious for its orgies and black magic.

It is thought that Bates may have been physician to the founder of the Hell Fire Club, Sir Francis Dashwood, as in 1781 he gave up his medical practice to accompany Dashwood on a tour of Europe, being promised a large annuity for his services. Unfortunately Dashwood died before the tour began, leaving Bates in financial difficulties with no annuity and no means of re-establishing his medical practice.

Bell Inn – A True Survivor

One of the features in Market Square is this attractive inn, which has been in existence since the late fourteenth centenary, probably on its present site. Interior beams show that the building dates from medieval times and was mentioned in the fifteenth century when there were numerous inns and taverns in the vicinity.

Inside, customers can see various pictures and photographs showing the history of Aylesbury together with a photograph of the horse fairs held outside the inn, still popular until the twentieth century.

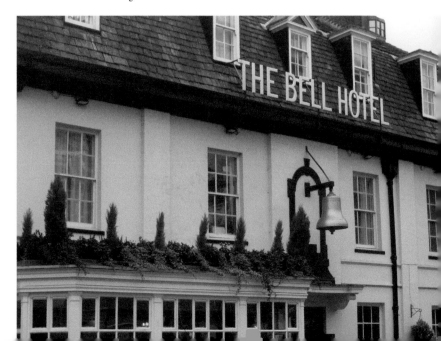

The Bell Hotel, Market Square.

Reflections on the glass at the
Blue Leanie.

Blue Leanie – A Good Idea at the Time

This iconic modern-looking building gained notoriety when it was first built in 1982.
The office block is made of glass and brick, has slanting walls, and was claimed to be a
potential hazard to motorists when the sun reflected onto its large mirrored surface.
Reports of the danger even reached the national newspapers. The problem was solved,
however, by planting a row of mature trees in front of the building, making it a far
more picturesque and safer site.

The workforce inside occasionally suffer from the heat caused by the sun through
the windows, which can reach up to 35 degrees centigrade when the air conditioning
fails. However, from the outside the massive panes of glass make a beautiful picture
reflecting the trees outlined against the sky.

Boleyn, Anne – Her Secret Hideaway

Clandestine meetings between Anne Boleyn and Henry VIII were said to have taken
place in a cottage in Stoke Mandeville, Aylesbury, as well as at her family home at
Hever Castle in Kent.

Anne's father, Sir Thomas Boleyn, owned Aylesbury Manor as well as many other
properties in the area. In 1529, in an effort to curry favour with him, Henry VIII gave
Aylesbury the official title of county town of Buckinghamshire, taking the title away
from Buckingham.

The cottage, built in 1409, still has its original bread oven and stained-glass windows
depicting Elizabeth I and Edward VI.

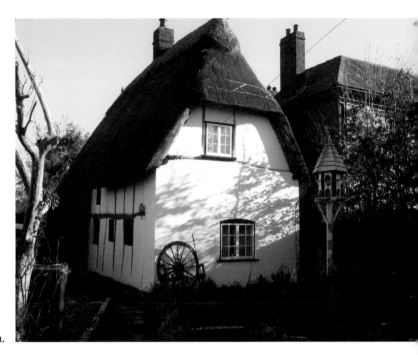

Secret meeting place
of Henry VIII and his
mistress Anne Boleyn.

Boughton, Rutland

Rutland Boughton was a well-known composer who rose to fame in an unexpected place. The son of a grocer, he was born in Aylesbury in 1878. His father and uncle ran the grocery shop in Buckingham Street close to the grammar school which he attended until the age of fourteen.

His musical talent was noticed by composer/conductor Sir Charles Stanford who persuaded the local MP, Lord Rothschild, to help raise funds for the young Boughton to attend the Royal College of Music in London.

The Immortal House, His Bethlehem, written in 1915, is his best-known opera although he also wrote a series of five operas based on the Arthurian legends, which took him thirty-five years to complete.

Surprisingly it was at Glastonbury where he performed his first opera from the Arthurian cycle *The Birth of Arthur*, a fitting location for such a performance, and it was from here that he established the country's series of Glastonbury festivals. These proved to be extremely popular and ran from 1914 to 1926.

Inspired by the history of the English Civil War and Aylesbury's part in it, he composed *Symphony No 1 'Oliver Cromwell'* to celebrate Cromwell's success.

In 1936 he was made president of the Aylesbury Choral Society. He had a daughter, Joy, who became one of the most accomplished oboists of her generation. She died in 1962, only two years after her father's death.

Boughton was a prolific composer and many of his works are still available today.

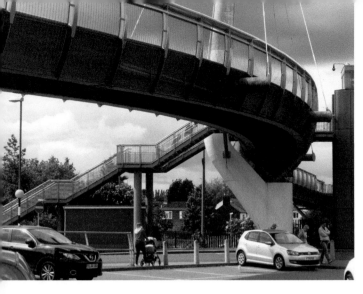

Bourg Walk, a masterpiece of engineering.

Bourg Walk – Engineering at Its Best

The footbridge spanning the railway and linking Southcourt to the town centre was opened in 2009 after six months of consultation to decide on a name. The bridge was finally named after Aylesbury's twinned town in France, Bourg-en-Bresse.

This impressive piece of engineering has a central pillar with four suspension cables supporting its structure. It won the Engineering Excellence Award 2009 presented by the South East England branch of the Institute of Civil Engineers.

Bowie, David– The Reinventing Pop Idol

Statues of various notable persons throughout history have found their way onto the streets of the town but something entirely different is the David Bowie art installation situated under the historic arches at the bottom of Market Square. Titled *Earthly Messenger*, it was designed and sculpted by Buckinghamshire's Andrew Sinclair, who created the likeness by using the mask from the filming of *The Man Who Fell to Earth*.

The installation was unveiled in March 2018, with David Bowie tracks being played through an audio system, to commemorate Bowie's connection with the town. Bowie had the ability to constantly reinvent himself and it was at Friars music club in 1971 where he performed his world debuts of 'Hunky Dory' and 'The Rise and Fall of Ziggy Stardust and the Spiders from Mars'. Bowie referenced the Market Square in Aylesbury in the first line of the Ziggy Stardust album *Five Years*.

He was bisexual, transgressive, colourful and totally different from all previous artists in the world of music. 'Be who you want to be. It's OK to be different,' he was reported as saying in the *Melody Maker*, a popular magazine at the time. He died aged sixty-nine, two days after releasing his last album.

Such was his following in the town that it is said that shortly after his death from cancer of the liver a petition was started to rename the town Aylesbowie!

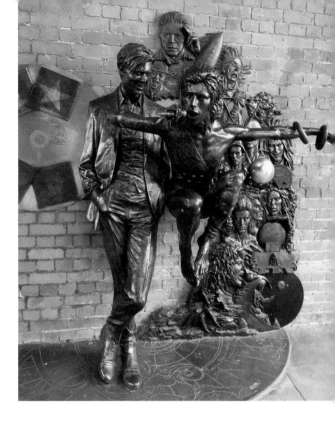

David Bowie musical art installation.

Bucks Herald – Outlasting All the Competition

An epidemic of cholera didn't stop the *Bucks Herald* from its first issue being published in 1832 at a cost of seven pence in old money for four pages. The cholera epidemic eventually passed but the local newspaper kept going, beating off its competitors the *Bucks Gazette* and later the *Bucks Chronicle*. This was the only newspaper in the area that supported the Conservative Party and reported on the news of the established church, the Church of England.

At its launch it sported the full title of *The Bucks Herald, Farmers' Journal and Advertising Chronicle for Bucks, Beds, Herts, Berks, Oxon, Northampton*. It accepted advertisements from all trades and services, completely filling the front page – as was the custom – and did so for the next 100 years.

It continued to reduce its cost and increase its number of pages, charging only one penny per copy in 1912. The First World War forced the newspaper into printing a very thin sheet; however, it continued to grow in popularity and the proprietors received good wishes from Queen Elizabeth II and Margaret Thatcher PM when it celebrated its 150th anniversary in 1982.

To keep in with the trend of smaller newspapers it changed from a broadsheet to a compact format in 2012 but still publishes on a weekly basis as well as printing a free *Bucks Advertiser* each week.

Castle Street – With a Missing Castle

This is a strange name for a street without a castle; in fact there is no proof of there ever being one in Aylesbury. Records show that this road was once called Catte Street in the early nineteenth century, which was possibly a shortened version of Cattle Street since sheep and cattle were driven along here on the way to Market Square.

As this was the main thoroughfare into the town centre from both Thame and Oxford, the road was lowered to make it easier for horse-drawn vehicles to climb the hill. The raised pavements are still here today stretching along the sixteenth-, seventeenth- and eighteenth-century cottages.

Lowered road in Castle Street to aid livestock.

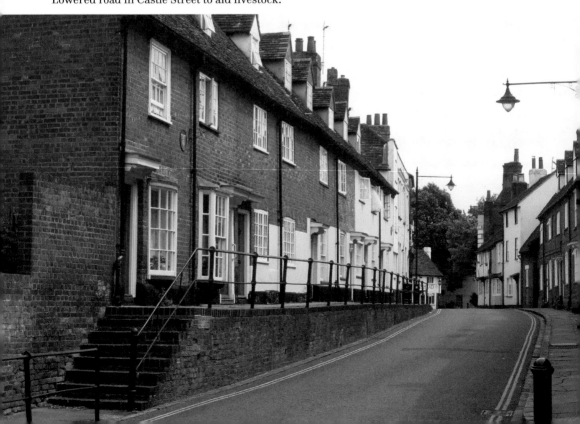

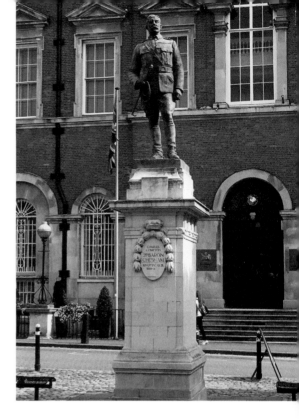

Lord Chesham statue standing on duty outside the old County Hall.

Chesham, Lord – Distinguished Officer

A bronze statue of Lord Chesham in undress uniform of a General Officer stands in Market Square flanked either side by recumbent lions donated by the Rothschild family.

Charles Compton William Cavendish was born in 1850 in London and joined the Coldstream Guards at the age of nineteen. He represented Aylesbury in the House of Commons as a Liberal. After a distinguished career he became a Member of the House of Lords and led the 10th Battalion of the Imperial Yeomanry in the Second Boer War in 1900.

He was involved in a hunting accident near Daventry in 1907 when his horse failed to complete a jump. He fell on his head and broke his neck.

He will be remembered as a British soldier, courtier and Conservative politician.

Clock Tower – Keeping Time over the Market

An ideal place for public speaking was in Market Square where men could stand on the raised dais around the bottom of the clock tower. The Victorian tower was built with local stone in 1876, in Gothic Revival style complete with spire, by architect D. Brandon who also designed the nearby ornate Corn Exchange.

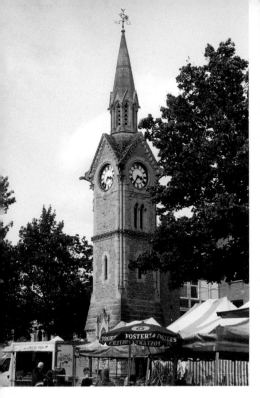

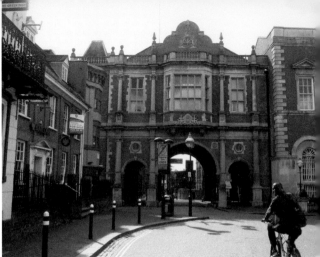

Above: Corn Exchange, Market Square.

Left: Clock tower rising above Market Square.

Corn Exchange – Linking the Old and the New

The impressive Corn Exchange featuring three elegant arches was opened in 1865, replacing the White Hart Inn next to the gaol. It was originally used for buying and selling corn and occasionally for badger baiting and cock fighting. However, five years after opening the agriculture depression began to take hold and the drop in the value of corn forced the building to be sold and used as a town hall by the Urban District Council. Today it houses the council conference rooms.

Through the arches can be found the David Bowie art installation and the new Exchange restaurant and entertainment area.

County Council Offices – The Council with a Heart

The Brutalist style of architecture, sometimes referred to as the 'celebration of concrete', is an apt name for the design of the County Hall in the centre of the town. Standing twelve storeys high, this 200-foot tower is built above the County Reference Library, the Register Office and the County Records Office. It was unveiled in 1966 and cost £956,000 to build.

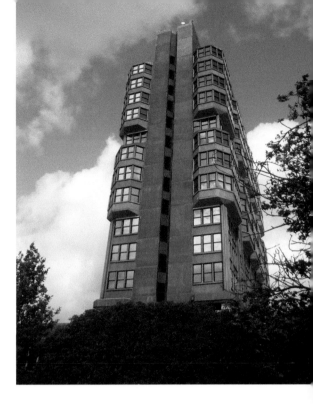

Stark offices of the County Council.

As it can be seen from miles around, it created much controversy when the plans were first shown. The architect, Fred Pooley, has had to suffer the indignity of his concrete and glass building being nicknamed Pooley's Folly or Fred's Fort.

Not so scathing are the Peregrine falcons who have been nesting at the top of the building for over ten years. The council have even built a platform where they and their chicks have a larger area for nesting and can remain protected.

County Hall and Courthouse – Lawfully Dominating the Town

This handsome Palladian-style building overlooking Market Square has been strangely punctuated by drainpipes placed between the windows. When the construction work began the town's inhabitants probably were not so concerned with its looks but more worried about the cost. It was started in 1725 but not finished until fifteen years later in 1740. Taxes were raised a number of times to cover the rising costs, but this proved to be an impossible task as many people defaulted on their payments, thereby halting all building work for a total of thirteen years.

Plans were originally produced in 1720 to convert an old house owned by William Benson which had been used as a rather inadequate gaol. A more secure gaol was planned but two years into the build it was decided to include the courts.

When completed this expensive landmark had three entrances: the eastern doorway led to the passage to the gaol with five cells under the central court, and the central

door was used for the Clerk of the Peace and the magistrates. The interior of both the central and western doors were armour plated and fitted with loopholes through which muskets could be fired in case of attack. Rioting was obviously a perceived problem.

Many prisoners convicted here were either sent to Australia or Tasmania. Those sentenced to death for robbery, rape or murder were hanged from the balcony at County Hall, which provided a long drop for the prisoner and plenty of viewing places for the general public. Probably much to the dismay of the blood-thirsty crowds gathered in Market Square the arrangement was changed in 1845 when prisoners were hanged inside the gaol. The balcony has since been removed.

The last person to be hanged in Market Square was John Tawell, who was found guilty of murder. He managed to escape and caught a train from Slough to Paddington. He was caught and rearrested, helped by the use of an electric telegraph which was the first time the device had been used for this purpose.

A bizarre sight greeted defendants on leaving the courtroom – there were two doors, one with a wooden carved happy face and one with a frowning sad face. Those sentenced to death were led through the sad-face door; others would have been relieved to be led through the happy doorway. It wasn't until the death penalty was abolished in 1965 that the doors were locked and remain locked today.

The most famous trial in Aylesbury's history took place in the Council Chamber in Walton Street as the courthouse was not large enough to accommodate all those wishing to hear the conviction of the Great Train Robbers in 1963–64. Other famous defendants have been Mick Jagger and Keith Richards of the Rolling Stones.

Above: Old County Hall and Courthouse.

Left: Entrance to the old Crown Court.

Cowbridge, William – Dying for his Beliefs

To be burned at the stake in Oxford was the sentence given to William Cowbridge at the Aylesbury Courts in 1538. He was known as a religious eccentric and accused of heresy, his crime being involvement in the publication of the Bible into the English language.

This controversial figure was one of hundreds condemned to death during the reign of Henry VIII and later by his daughter, Queen Mary. Cowbridge is remembered due to a witness, John Foxe, a martyrologist, who claimed that Cowbridge was starved and deprived of sleep in the Oxford gaol, thereby sending him mad.

Ironically, a year later the Bible was printed in English and authorised by Henry VIII to be read aloud in church services in the Church of England.

Cubitt Car – Prized Mode of Transport

From approximately 3,000 of these magnificent vintage cars, produced from 1919 to 1925, only around eight have survived, one of which is on display at the Bucks County Museum.

The Cubitt Engineering Company was founded in 1815 by Thomas Cubitt with his two brothers, William and Lewis. They were responsible for building such high-profile places in London as Covent Garden Market, the Cenotaph and the east wing of Buckingham Palace.

The engineering business was bought out in 1883 and became known as Holland, Hannen and Cubitts, making munitions for the First World War. By 1919 they had entered the motor industry, expecting a boom in car sales claiming that the Cubitt was an American-style car in an effort to build up competition against the new American imports.

A suitable factory was found in the town and work began on this new medium-power touring car. Depending on the model bought, the Cubitt was priced from between

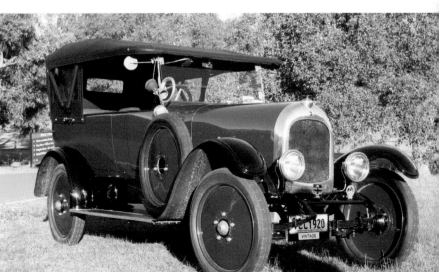

Cubitt car. (By kind permission of Adrian J. Fell)

£360 to £525 and could achieve the dizzying speeds of up to 50 mph. However, late delivery, sometimes as long as nine months, and problems with obtaining component parts added to its difficulties and by 1925 a receiver was appointed declaring Cubitt bankrupt.

Cycling – With Cycle Paths Galore

Pedal-power is given a strong emphasis in Aylesbury as it is one of six towns awarded £17 million between them to promote cycling. The town had already invested in 14.1 km of cycle routes and these have now been promoted more vigorously with the inclusion of an extended network totally 24.4 km to date.

Popular destinations are the railway station, workplaces, schools and the town centre with the funding helping to make the environment more cyclist friendly. Existing routes have been expanded to reach surrounding villages, and traffic-free paths have been constructed as well as on-road cycle lanes.

The project, locally named Cycle Aylesbury, has involved businesses and schools, providing extra cycle parking spaces, route maps and cycle safety training. Even The Exchange, the newly built area through the arches in Market Square, has its own unique bike rack etched with the inspiring words 'I am pedalling to make the grey matter sparkle ...'

The Aylesbury Cycling Club has been in existence for over fifty years giving weekly road training sessions throughout the summer as well as providing cyclists with training for hill work and general fitness.

Never has the saying 'On your bike' been more appropriate!

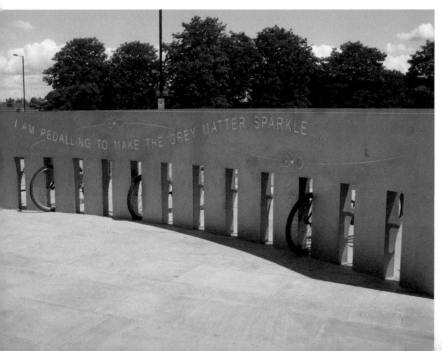

Contemporary cycle rack in The Exchange.

D

Dead House – A Healthier Ritual

The population increased rapidly during the Victorian era and St Mary's churchyard was overflowing. There was nowhere left to bury the dead. The town's first cemetery was created in New Road – now Tring Road – in 1858 when the Church of England area was consecrated by the Bishop of Oxford.

The Gothic-style Dead House served as a mortuary until burial could take place, replacing the unhealthy ritual of keeping the deceased family member in the house. In winter when the ground was too hard for digging, bodies could spend months in the Dead

Below left: The Dead House, Tring Road cemetery.

Below right: Gothic-style chapel, Tring Road cemetery.

House but these securely locked buildings also prevented grave robbers from stealing corpses as many had decomposed beyond use for dissection by the time they were buried.

The opulence of this era also extended to its burial grounds, providing a pleasant green community space as well as a place to bury the dead. Two chapels were built in the grounds – one for the episcopal community and one for dissenters – but despite this religious division the tree-lined paths and landscaped area was possibly enjoyed by many of the population who could spend a pleasant Sunday afternoon strolling through the gravestones, as was the fashion at the time.

Derby Arms – Putting on a Proud Front

A secret lies behind the front of what was once known as the Derby Arms, or rather, the secret lies in the frontage itself. This Georgian-looking building, with its sash windows, two-tone brickwork and a triangular pediment set above the fashionable doorway, is the epitome of Georgian grandeur. However, the side view shows that this is a false front behind which is a much older house with a pitched roof. This was a trend during the Georgian era where houseowners wished their homes to be at the height of fashion but were unable to afford a complete renovation.

Side view of the Derby Arms.

Disraeli, Benjamin– The First Jewish Prime Minister

Disraeli had always dreamed of becoming Prime Minister even though the law excluded him. He was Jewish and it wasn't until the law changed in 1858 with the passing of the Jewish Relief Act that his dream became a reality. He was MP for Buckinghamshire, Chancellor of the Exchequer and Prime Minister twice, making him the country's first and, to date, the only Jewish leader.

He fought hard for his position against his arch rival William Gladstone, who was continually hot on his heels, but it is said that he fought bravely against anti-Semitic attacks and revived a failing Conservative Party.

His statue stands in the same corner of Market Square as John Hampden's, where they face each other; both were made by the same sculptor, H. C. Fehr. The statue was first proposed in 1913 but original plans were stopped when war broke out in 1914. The work was completed in 1923 and shows him wearing the robes of the Chancellor of the Exchequer.

Disraeli was a superb speaker, wrote many books – including novels – and was honoured to be known as one of Queen Victoria's favourite politicians.

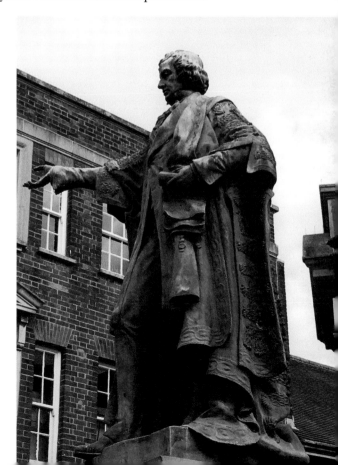

Benjamin Disraeli statue, Market Square.

English Civil War – The Battle of Aylesbury

The people of Aylesbury supported Parliament during the English Civil War. Sir William Balfour, Parliamentarian, and his army of 1,500 men came from the north to defend the town. Prince Rupert, who had been sent to fight on behalf of Charles I, entered Aylesbury on his way back to London after the Battle of Edgehill. Aware of the politics of the town, he thought the inhabitants might attack his men, so he planned to meet Balfour at Holman's Bridge.

The Royalists vastly outnumbered the Parliamentarian detachment but in November 1642 Sir William Balfour's force, aided by the men of Aylesbury, attacked the Royalists from behind. Two hundred Royalists were killed during this battle and less than half that number of Parliamentarians.

Prince Rupert was forced to retreat to Oxford, but a month later a faction of his army returned to Aylesbury to plunder and wreck the houses. Armed with muskets and pikes the townsmen and those from the surrounding villages drove out the soldiers. By 1643 Aylesbury was garrisoned by Parliamentary troops and although Prince Rupert marched towards the town that same year, he dared not attempt to enter it again.

However, Aylesbury 'was much in the King's eye' and Prince Rupert had been promised its surrender by the Independents. In a snowstorm in January 1644 the Royalists once again advanced on the town but realising their plot had been discovered and their plans thwarted, they fled.

Throughout the English Civil War makeshift defences of earthen ramparts were built to protect the town, although this entailed demolishing a number of houses including the manor house.

In 1651 Oliver Cromwell was met by Parliamentary delegates in Aylesbury to be congratulated on his victory. He stayed at the King's Head Coaching Inn where the landlord gave out anti-monarchy tokens to be exchanged for ale. A chair said to have been used by Cromwell can still be seen at the inn.

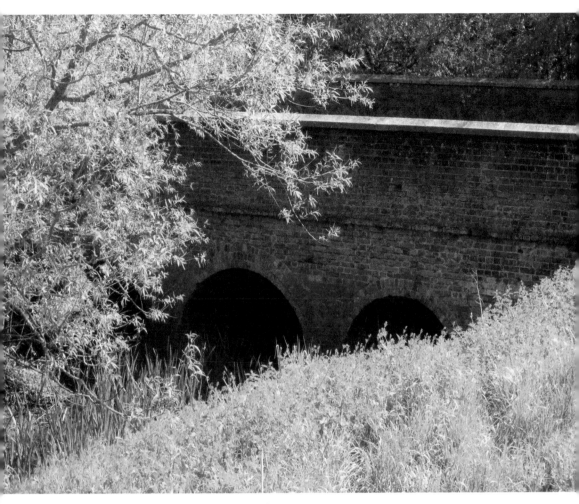

Holman's Bridge, site of the Battle of Aylesbury.

Nearly two centuries later, in 1818, bones were discovered near the site of the battle at Holman's Bridge belonging to 247 fallen soldiers from both sides of the conflict. The remains were collected and placed in a tomb in Hardwick churchyard.

Franciscan Friary – Remembered to This Day

A former Franciscan friary in Rickfords Hill has the honour of being the oldest residential building in Aylesbury. It looks rather uninspiring and although it was originally constructed around 1386, the front has been modernised at least twice, giving it a bland exterior saved only by the ornate doorway.

Also known as Greyfriars from wearing grey habits, they lived in total poverty relying on others for food and other necessities, and in turn they helped the poor and the sick. They were given a total of 15 acres for the friary, which they later leased out in small lots to tenants. However, by 1538, with the Dissolution of the Monasteries already in progress, the remaining nine friars were forced to publicly denounce their way of life, dismissed from the friary, and left with very little pension.

Apart from the building in Rickfords Hill, Friars Square Shopping Centre, built in 1966 by the side of Market Square, is also a reminder of the friars' much-needed charity work.

Below left: Franciscan friary, Rickfords Hill.

Below right: Ornate doorway, complete with friar.

Friars Nightclub – The Place to Be Discovered

Both new and established rock and pop bands would all want to be seen in Friars Nightclub. With its friendly atmosphere and an audience of genuine music lovers the nightclub appealed to bands from all over the country making Aylesbury the second most popular venue outside London.

Founded in 1969 by David Stopps, who also managed Howard Jones for twenty-five years, his long contact list enabled him to sign up such acts as David Bowie, Queen, Genesis, The Jam, The Ramones, Iggy Pop, Roxie Music, U2, The Police, Blondie, The Kinks and Dire Straits amongst many others.

The venue also supported new acts who could be assured of being seen by record company managers and producers. The eclectic mix of performers booked by David ensured that there was always something of interest for everyone.

Reunion gigs were organised in 2009 and similar events are now held in the new Waterside Theatre.

Font – Named after Aylesbury

The Norman font in St Mary's Church is one of the finest designs in what is now known as 'Aylesbury Fonts' in the country. There are approximately twenty-two others of similar chalice shape in neighbouring counties, but this example, dating from approximately 1180, was found buried in rubble underneath the church.

The decoration features a fluting pattern on the bowl similar to that of the twelfth-century doorway at St Albans Abbey, thereby suggesting that the craftsmen could have been trained in St Albans. Sitting on a square base with semicircular cushions, it can now be found on a rather incongruous stage on the west end of the parish church.

Below left: Friars Club mural, Friars Square Shopping Centre.

Below right: Aylesbury font, St Mary's Church.

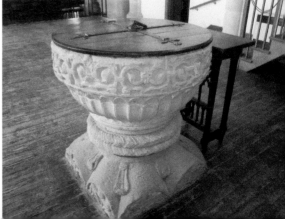

Gallows Road

Most ancient towns had a notorious plot of land where prisoners receiving the death penalty were sent to the gallows. Gallows Road was a quarter of a mile from the town, where the public could gather to watch the then entertaining sight of prisoners being hanged. Later, prisoners were hanged from the balcony at County Hall, a far shorter distance for spectators to walk. Today the thoroughfare has the more conservative name of Bicester Road.

Garden Town – A Green and Pleasant Land

The idea of Garden Cities was the brainchild of English town designer Ebenezer Howard who wanted to improve the amenities of those living in rural areas but at the same time bringing greener spaces and a healthier environment to urban areas. Howard's plans were to build small, well-planned, sustainable towns surrounded by green belt areas.

Colourful houses in Watermead.

Aylesbury was awarded Garden Town status in January 2017. The town proposes to provide an additional 16,000 homes by 2033 with increased open spaces, more trees and walking and cycle paths within its boundaries, and is being recognised as one of the main areas for growth in the UK.

Newcomers to the area, including businesses, will still be surrounded by the panoramic countryside with proximity to the Chiltern Hills, an Area of Outstanding Natural Beauty.

Gaol – The Cost of Safety

A house in Market Square owned by William Benson had been converted for use as the town's gaol; however, the building was too small to hold many prisoners, neither was it safe. Escaped felons could claim sanctuary in St Mary's Church and receive safe conduct overseas, including those condemned to death. In 1276 the current gaoler even allowed women to escape at a cost of one shilling each.

A new, more secure building had to be planned. Eventually it was decided to use the current site and £600 was paid to Mr Benson although he had originally asked for £1,000. Plans were drawn up in 1720 and local taxes were increased to one penny in the pound, later to two pence, and later still a further two pence was added. Two years into the build it was decided to change the plans – the structure would now include courts, adding even more expense.

By 1724 work on the building stopped. The money had run out. It was discovered that some of the residents had not been paying their taxes so an Act of Parliament was obtained to ensure that all monies were received. The Act took five years to obtain.

Meanwhile the workmen were not being paid and by the time they received their dues in 1737 a number of the creditors had died. This fiasco lasted for twenty years, thirteen of which no building work was done at all. The courthouse and gaol was not completed until 1740, and it had cost approximately £8,000, a huge sum in those times.

Punishment for prisoners sentenced to hard labour was a problem. There was no suitable work available, so a 20-foot-diameter treadmill was erected inside the gaol. Two gangs of men would work twenty minutes on and twenty minutes off grinding corn and pumping water for the town. The treadmill was condemned in 1841 after a number of fatal accidents. Prisoners would also be made to pick oakum, which consisted of unpicking rope, making rope mats and breaking up large rocks and stones. Low-risk prisoners were allowed outside the gaol to work on excavating grounds for a lake for the Clerk of the Peace who must have saved a fortune with his free labour.

One of the perks of prison life was that the gaol was built next to the White Hart Inn. Alcohol could be passed through the window of the inn to the prison yard – an illegal act in the nineteenth century.

A report written in 1843 found the old gaol inadequate and a new prison was built in Brierton Road where the prisoners could be kept in comparative comfort and safety, but unfortunately without the White Hart ale.

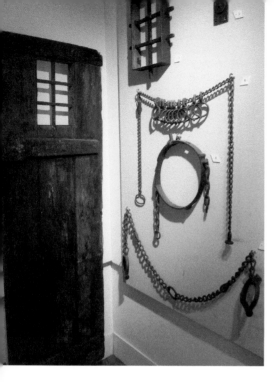

Gaol door, window grill, gang chain, and restraining belt at Bucks County Museum.

Govier, James Henry – An Artist with a History

Making models for the Dambuster raids and the D-Day landing craft during the Second World War must have been exciting and rewarding work for James Govier. As an accomplished artist and etcher he had the privilege of attending the Royal College of Art, but his career was interrupted when he joined the Royal Engineers in 1940. He originally constructed gun emplacements and helped in the development of chemical warfare, but two years after joining he was transferred to the model-making section of the Royal Air Force.

Govier was demobilised in 1945 and exhibited his paintings and etchings with the Aylesbury and District Art Society. Pictures of the town during the 1940s and '50s can be seen in Bucks County Museum.

Grammar School – A School of Many Parts

The date of the founding of the grammar school in Church Street is uncertain; however it is known that the first recorded schoolmaster in 1678 was Obadiah Dumea. One hundred and twenty boys were taught there for ten hours a day, 100 boys on free placements being taught reading, writing and keeping accounts. The remaining twenty

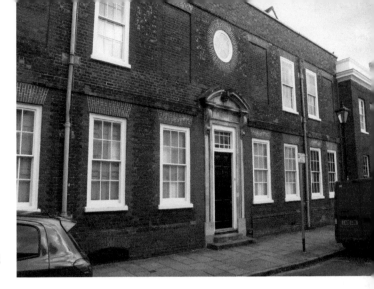

Headmaster's house, now part of Bucks County Museum.

whose parents could afford to pay for their education were taught Latin, Greek and Hebrew. Boys could start school from the age of five providing they could already read.

The grammar school was used as a military hospital for part of the First World War and now forms part of the Bucks County Museum and Art Gallery.

Grand Union Canal – Changing the Face of the Town

The Aylesbury branch of the Grand Union Canal was possibly used to transport slaves when it was first opened in 1814. Taking a year to complete, plans for a new arm of the canal began in 1793; however there was much opposition to its construction. Water was at a shortage but with the help of the nearby reservoir and an injection of £1,000 given by the Marquis of Buckingham the fight was won.

This section of the canal begins its journey at Marsworth on the border between Buckinghamshire and Hertfordshire, just over 6 miles from Aylesbury. With an almost 95-foot drop, the canal travels through sixteen narrow locks and under nineteen bridges. One of these bridges leads to Long Marston where in 1751 the last witch hunt in England took place.

John and Ruth Osbourne were accused of being responsible for a local farmer's failing crops. At the age of seventy, poor, elderly, and living in the workhouse, they were stripped of their clothing and with their hands tied to their feet they were thrown into a pond, possibly at nearby Wilstone. This was known as ducking – those who survived were considered innocent but those who drowned had met their rightful end.

This act had already been outlawed by Parliament in 1736 but those in authority turned a blind eye. Ruth Osbourne died by choking in the mud and her husband, who was tied up with her in a sheet, died soon afterwards.

Today, the canal is used mainly for recreation with canal boats and narrowboats busily navigating the waterways possibly unaware of its murky past.

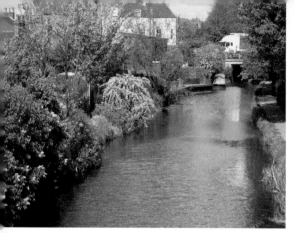
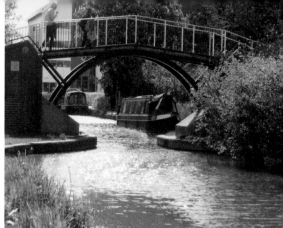

Above left: Grand Union Canal.

Above right: Bridge over the canal leading to the town.

Great Train Robbery – With Undiscovered Money

Dubbed the 'Crime of the Century', one of the most famous and biggest robberies in history took place in 1963 just outside the town. A fifteen-strong gang of men tampered with the railway signals at Mentmore Bridge, thereby halting the Royal Mail train on its way from Glasgow to London. The gang broke into the high-value package coach taking approximately 120 mailbags filled with £1 and £5 notes. The total value of the theft was over £2.6 million, the equivalent of approximately £50 million today.

Although no weapons were carried, the train driver, Jack Mills, was hit over the head and suffered severe injuries.

The gang hid out at Leatherslade Farm where, judging by the amount of food recovered, they intended to lay low until it was safe for them to leave. However, they

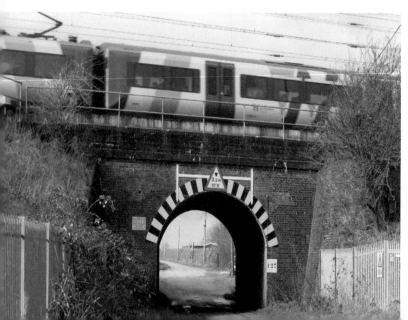

Mentmore Bridge, scene of the 1963 Great Train Robbery.

were forced to abandon the farm in a hurry. Suspicions were aroused by the locals, the police found their hideout, and incriminating fingerprint evidence on a Monopoly board and a ketchup bottle aided the police in the robbers' capture.

Twelve of the gang were put on trial at Aylesbury Assizes in 1964 but the court proved to be too small for the proceedings. It was transferred to the nearby Rural District Council chamber, which was altered to accommodate the three-month hearing. Only one man pleaded guilty and the remaining eleven were sent to prison for between twenty and thirty years each.

The sentencing took place at Aylesbury Crown Court and was presided over by Mr Justice Edmund Davies. Less than £400,000 of the stolen money was recovered. Perhaps the remaining amount is still hidden somewhere near the town!

Green End House

This seventeenth-century house was extended a century after it was built and still contains some of the original fittings. Home to William Rickford, owner of the first bank in the town, it previously belonged to the local doctor, Dr Bates, who was also known as a member of the notorious Hell Fire Club.

Green End House was later purchased in January 2000 by the Thomas Hickman Charity.

The beautiful rear garden houses the remains of the original east window salvaged from St Mary's Church.

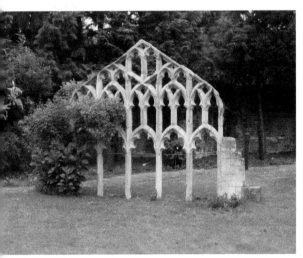

Above: Salvaged east window from St Mary's Church.

Right: Green End House.

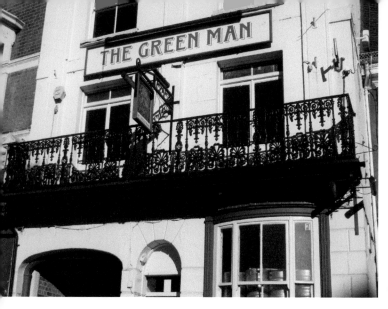

Spectators' viewing balcony, Green Man.

Green Man – Prime Viewing

The balcony at the Green Man public house in Market Square was used as a prime viewing platform to watch the punishment of those who were convicted of misdemeanours at the nearby County Court. From here people could watch hangings from one of the court windows as well as cheering on prisoners who were tied to carts and repeatedly whipped whilst being dragged to the top of Market Square and back.

Top rates were charged for viewing the execution of highwayman Galloping Dick from the balcony. Down below in Market Square up to 5,000 people regularly gathered to watch public hangings with an estimated 10,000 witnessing the very last execution in March 1845 of John Tawell, a notorious murderer.

On a totally different note, in the late seventeenth and early eighteenth centuries the old Green Man public house was kept by a female politician, Pat Alexander.

Guttmann, Sir Ludwig – Radical, Unique and Inspiring

Ludwig Guttmann was a remarkable man in many ways. In an effort to escape the persecution of the Jews in Germany in 1939 he, his wife and two children escaped to England despite having their passports confiscated. He had been working as a neurologist after being refused a military career on medical grounds but was forced into leaving the German hospital as Jews were forbidden to work in Aryan hospitals.

He initially found employment in Oxford until the government recognised his unique abilities with spinal injury patients and offered him Directorship of the new National Spinal Injury Centre at the Emergency Medical Services Hospital at Stoke

Mandeville. He accepted the post on condition that he could have total control over his patients, working on his own terms without interference. The government agreed.

The Spinal Unit opened in 1944 with twenty-four beds and one patient, but such was his reputation that within six months this number had increased to almost fifty. The patients were soldiers from the front line who had broken necks or broken backs and had been given a two-year life expectancy. The breaks themselves were not the cause of death, rather the pressure sores and urinary tract infections.

Dr Guttmann soon realised that being confined to bed all day had an adverse effect on his patients. He came up with the radical idea of encouraging them to stimulate their minds with woodwork and clock and watch-repairing workshops. However, the most inspiring idea of all was to get the men outside in the fresh air playing sport in their wheelchairs.

The first sport organised was wheelchair polo using walking sticks and a puck. He then encouraged them with wheelchair basketball followed by archery. The results were astonishing and sport became compulsory at the hospital. Dr Guttmann was not a man to argue with; he had a strong personality, total control over all his patients, and a manner that terrified the nurses.

However, his ideas on rehabilitation were life-changing. He organised annual matches for his physically impaired war veterans and in 1948 introduced the Stoke Mandeville Games at the opening ceremony of the London 1948 Olympic Games. By 1960 the Games were renamed the Paralympic Games, which were held in Rome featuring 400 athletes from twenty-three different countries.

'If I ever did one good thing in my medical career,' Dr Guttmann is quoted as saying, 'it was to introduce sport into the rehabilitation of disabled people.'

A bronze bust taken from a moulding of the statue outside the hospital was presented to the International Paralympic Committee who display it at every Winter and Summer Paralympic Games throughout the world.

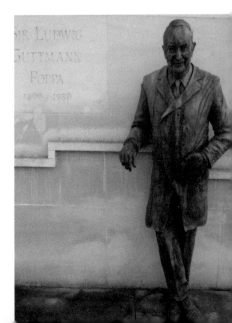

Sir Ludwig Guttmann's life-size statue with space for wheelchair users.

Hampden, John – Admired for His Stand Against the King

As cousin to Oliver Cromwell, it is not surprising that local MP John Hampden was a Parliamentarian. Charles I had tried to extend the Ship Tax to include inland counties in an effort to expand the Royal Navy. Representing a county far from the coast, John Hampden refused to pay, which won him the respect of the people of the town.

Hampden was also one of the main revolutionaries against the king in the English Civil War where his eighteen-year-old son lost his life defending Chenies. Aylesbury was defended by the largest garrison in the county and became an important centre for military operations.

John Hampden's statue, erected in 1912 and featured on much of Aylesbury's promotional literature, stands at the north-east corner of Market Square. His family's motto, *Vestigia nulla retrorsum* (No backward step), is used on the heraldic emblem for Buckinghamshire.

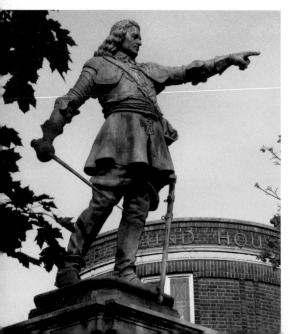

John Hampden statue, Market Square.

Harding, William – A Charitable Man

Walton was once a small village on the outskirts of Aylesbury. William Harding, a yeoman farmer, owned a sizable amount of land and properties in and around the village. One of his responsibilities was supervising the relief for the poor under the Poor Law Act of 1601.

In his will he requested that approximately five poor children be selected twice a year to be provided with ten pounds each for clothing and an apprenticeship. The girls presumably went into service, but the boys were trained to become blacksmiths as well as shoe and glove makers, tailors, saddlers, carpenters, bakers, barbers and periwig makers. Trades in hemp dressing and spinning were included for the boys.

Adults were also helped. Each year on St Thomas' Day, 21 December, two pounds was spent on warm winter coats, which were distributed from The New Inn, now renamed The Broad Leys Pub.

Part of Harding's land was either sold or requisitioned during the Second World War. It was during this time that the only German bomb to fall on Aylesbury landed in Walton. The 15-lb bomb destroyed the medieval Walton Grange and many of the nearby houses. However, in peacetime the price of land increased and so did Harding's inheritance. The Harding Charity is still helping both disadvantaged children and the elderly with grants and money towards other worthwhile projects.

Above: The New Inn, now renamed The Broad Leys Pub.

Right: Village pond by William Harding's house, part of his estate.

Holy Trinity, Walton – Another Overflowing Church

St Mary's Church in the old part of town was becoming overcrowded every Sunday to such an extent that it was decided a second church was needed to accommodate the expanding congregation.

Holy Trinity Church was built half a mile away in what was then the village of Walton, now part of the main town. The building was completed in 1844, the congregation consisting of the poorer people of the town, the boat families working and living on the canal, the labourers, and the farmers who bred Aylesbury ducklings.

A friend of the vicar loaned the church enough money to buy two cottages next door for use as a school, now renamed Walton Hall and still used as a thriving community centre.

It wasn't long before the size of the new Holy Trinity Church also proved to be inadequate. According to a census their morning and evening congregation totalled 732, so additions to the church were made comprising of a gallery, a baptistery, porch and tower with three bells.

Below left: Holy Trinity Church, Walton.

Below right: Contemporary stained-glass window, Holy Trinity Church.

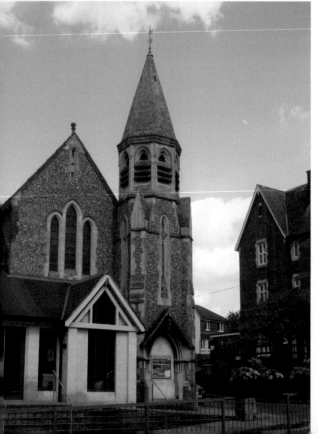

I

Iron-Age Hill Fort – The Beginning of Aylesbury

The first settlement in the area dates back to 650 BC. Later, the Iron-Age Celts arrived in the fifth century BC. The site chosen was a hilltop where they built a fort surrounded by a deep ditch, which was then enclosed by an earthen mound for defence. This covered the inner core of the medieval town but not what is now known as Market Square.

During excavations in 1985 a severed head was found in the ditch, the carefully positioned skull and the nature of the cut showing that this was deliberate slaughter. Inside the fort at least five human bodies and the remains of approximately thirty animals were uncovered, giving evidence of a gruesome ritual.

The first significant inhabitants were from the Bronze Age, and in AD 571 the Anglo-Saxons gave the village the name of Aylesbury, probably spelled Aiglerburgh, although over the years the town has had fifty-seven different spellings.

Italianate Methodist Church – Big, Bold and Proud

Built in 1894 to hold a congregation of 710, this Methodist church is remarkable in its design. It is usual for buildings of this denomination to have a plainer exterior, but this church breaks all the rules. Sited in Buckingham Street, it also boasts Byzantine and Romanesque features, although it was once unkindly described by Sir Nikolaus Pevsner, who originally wrote forty-six volumes on British and Irish architecture, as having a 'terrible Italianate style'.

By the 1950s the upper sections of the building were suffering from dry rot, forcing the gallery seating and other parts of the church to relocate to the ground floor.

In the 1980s a section around the vestibule was enlarged followed almost thirty years later by extensive alterations to both the church and the attached community centre.

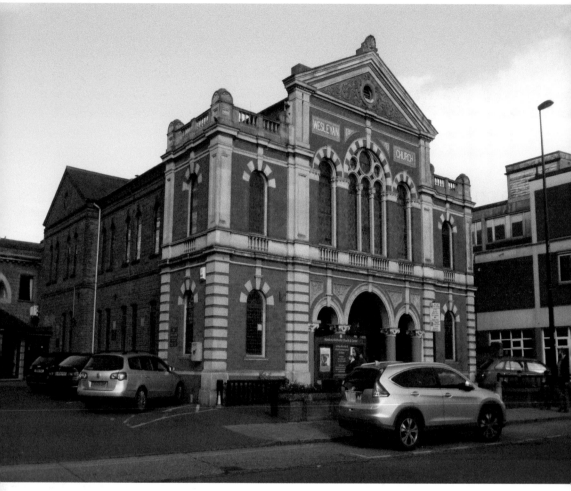

Methodist Church and Centre, Buckingham Street.

Although accommodating only 350 seats – half of the original number – the church still has a vibrant, diverse and friendly congregation, with ample space for accommodating their numerous community groups.

J

Jacobean Mansion of Hartwell – With French Connections

The most famous resident at the Jacobean-styled Hartwell House was King Louis XVIII, the exiled King of France. He escaped from Paris during the French Revolution in 1791 and settled in England after travelling around Europe. Sir Charles

Hartwell House and landscaped gardens.

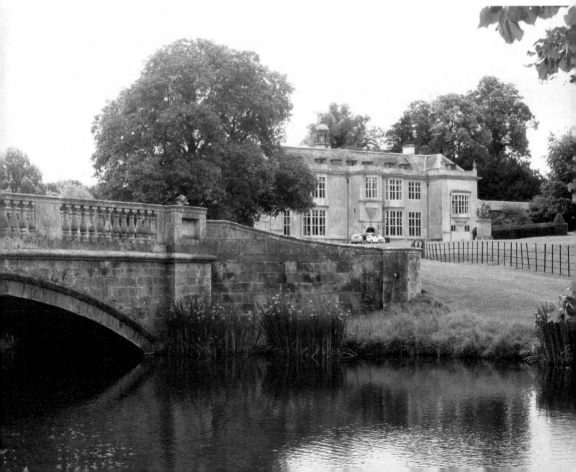

Lee was the current owner of the mansion and he allowed the king and his wife, Marie Josephine of Savoy, to stay there from 1809 to 1814 along with 140 members of their family and servants, including the exiled King of Sweden.

The King of France's large entourage was of great benefit to the local merchants whose increased sales of provisions and services must have been a great boon for the tradesmen of the town.

Sadly, after only a year at Hartwell House, Queen Marie died – the only French queen to have died on English soil. Her body was taken to Westminster Abbey and a year later transferred to Sardinia where she was buried in the Cathedral of Cagliari.

Happier times were to come at the mansion when the British army entered Paris and restored the House of Bourbon to the throne of France. The signing of the Treaty of Paris by Louis XVIII ended the Napoleonic Wars.

The sudden departure of the French must have taken its toll on the local economy; however Waterhouse Street, housing the horse-powered pump and cistern for the town's water, was renamed Bourbon Street in honour of the French king.

Judges' Lodgings

With evermore bureaucracy falling upon the courts over the years, the County Hall, although large inside, soon became inadequate to cover all the procedures required of it. Behind the County Hall the judges' lodgings were completed in 1850 in place of the gaol, which moved to its present site in Brierton Road. The courtroom and judges' lodgings were linked by a bridge. Almost in front of the judges' front door is the rather scruffy entrance for the prisoners to be led down to the cells awaiting their hearing – although not so scruffy for Judge John Deed, who did much of his filming here.

Judges' Lodgings with linked bridge to the County Court.

K

King's Head Coaching Inn – The Oldest Pub in Town

The King's Head is probably the most well-known public house in Aylesbury. It's certainly the oldest. Dating back to the fifteenth-century with cellars thought to originate from the thirteenth century, this coaching inn has an intriguing history.

Part of the building, where the Farmer's Bar is now situated, was originally three shops and a cottage with steps from the street leading to a cellar underneath one of the shops. Attached to these buildings was a hall and parlour on the ground floor with sleeping quarters above. Only the cellar remains today.

The tavern, named Kyngshede – presumably in recognition of Richard II, the reigning monarch – and the adjacent buildings were owned by William Wandesford, who bought the properties in 1455. He served in the household of Margaret of Anjou but as he was a Lancastrian during the Wars of the Roses, he was forced to forfeit his properties. It is thought that Henry VI and his wife Margaret of Anjou may have stayed at the King's Head whilst touring the country.

The Lord Mayor of London, Sir Ralph Verney, acquired the estate and from 1480 and for the next five years demolished many of the older buildings, bought land adjacent to the King's Head and built a Great Hall to accommodate his rich merchant friends from London. He later built extensions to the Great Hall adding a parlour, a secret room and a kitchen, as well as a gatehouse and stables to the outside.

With such luxurious accommodation Verney was able to attract many famous people such as Anne Boleyn, who was wooed by Henry VIII in 1533, possibly in the Solar Room above the Great Hall; Oliver Cromwell, who is reported to having stayed after the Battle of Worcester in 1651; and members of the Rothschild family.

Many interesting artefacts remain. The Great Hall features a superb stained-glass window consisting of five panes. The first is of Edmond Beaufort, soldier and supporter of Henry VI in the War of the Roses; the second, King Henry VI; the third, William de la Pole, Earl of Suffolk, who played an important role in the marriage of Henry VI to Margaret of Anjou. The fourth pane is of Margaret of Anjou, and the fifth of James Botlier of Ormonde, who was the descendant of the founder of the nearby

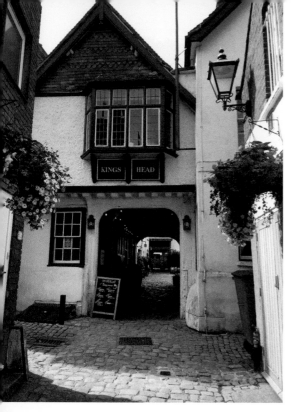

Left: King's Head Coaching Inn, King's Head Passage, Town Centre.

Below left: One of the few surviving inn yards in Aylesbury.

Below right: Eighteenth-century mounting block.

Greyfriar's monastery. Also depicted is the Bohun swan, the symbol of the House of Lancaster and that of the county of Buckinghamshire.

In the courtyard, one of the few surviving inn yards in Aylesbury, can be seen an eighteenth-century mounting block, a lamp holder for burning rags, hooks for unloading meat plus some of the original cobbles.

The inn was once part of the surrounding shops and inns in Market Square but building has taken place almost in front of the inn, which now has to be reached by a quaint cobbled passageway. Today the King's Head is one of the few public houses owned by the National Trust.

Kingsbury – A Square with a Difference

One of the main squares is that of Kingsbury, the centre of early settlement where the royal manor house stood in medieval times. The manor house survived until it was owned by Sir John Pakington, a Royalist in the Civil War. It was destroyed by the townspeople who supported Parliament.

Before this period, in 1332, the manor was given to the Earls of Ormonde whose great-granddaughter was Anne Boleyn. The Pakington family kept the manor for many generations, entertaining James I soon after he was crowned.

The square featured a water pump and was later replaced by a drinking fountain from 1914 until 1929 – now to be found in Vale Park. The theme continued in 2004 with the installation of a water clock, running throughout the paved slabs in the square. Sadly, it didn't last long. The fountain sprang a leak underground and the cost of repair was too great for the council to consider.

An English tank was displayed in Kingsbury from 1920, but when it was broken up in June 1929 it exploded – the welder was unaware that there was still fuel in the petrol tank. It is now a far more peaceful area where you can sit with a coffee and enjoy the sunshine, even without the water feature.

Coffee culture in Kingsbury Square.

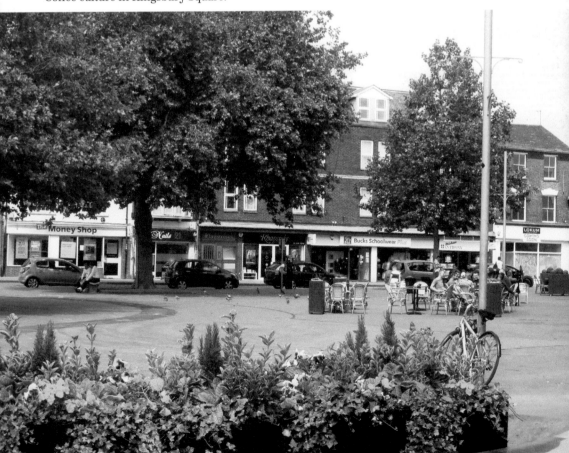

Lacemaking – Once a Necessity, Now an Enjoyable Craft

One of the most profitable cottage industries until the 1820s was the much-sought-after Bucks Lace. Buckinghamshire was the chief centre for lacemaking from the early sixteenth century, the design of lace changing depending on the latest fashion. Much of the lace was sold at London markets.

William Shakespeare refers to lacemaking in *Twelfth Night*, written around 1601–02, in which Orsino speaks of 'the free maids that weave their thread with bones'.

Above: Bucks Point Lace. (Lace made and image supplied by Jennifer Cooper)

Left: Lacemaking model, Bucks County Museum.

By the early 1670s lacemaking was being taught to children living in poverty and by 1698 the number of poor people working in this cottage industry rose to a staggering 429. It was made by all family members, especially those in the workhouse. This was an unhealthy job with adults and children pale-skinned and stooped from working indoors, continually bent over their work for hours.

The style known as Bucks Point Lace appeared at the end of the eighteenth century, influenced by the refugees fleeing here from France and Flanders. It is similar to French Lille lace, therefore often called English Lille. The arrival of the Industrial Revolution meant that lace could be made more efficiently by machines; however, it is still a popular pastime for needle-crafters today.

Lady Lee

Lady Lee was the wife of Sir Henry Lee QC, personal Champion of Queen Elizabeth I. In the sixteenth century he founded the Aylesbury free school and although there was once a monument to him, it disappeared many years ago. However, the monument to his wife, Lady Lee, dated 1584, stands in St Mary's Church in the north transept.

The memorial can be seen with Lady Lee kneeling with her daughter Mary and their two young children who died and were buried in their swaddling clothes. She asked that a red flower always be present on her memorial. Her request is still (almost) honoured to this day.

Memorial to Lady Lee with a pink rose, St Mary's Church.

Letterbox – The Proud Owner of Gold Paint

In celebration of the London Olympic Games and Paralympic Games in 2012 red letterboxes were painted gold in the home town of every gold medal winner. Eleven-time Paralympic gold medallist Tanni Grey-Thompson helped to paint the gold postbox outside Stoke Mandeville Hospital in honour of the birthplace of the modern Paralympic Games.

Library – A Drastically Changed Service

An expensive Circulating Library was founded in 1819 for the wealthy. Although perhaps not originally intended specifically for the well-to-do, the four guineas fee for joining and the annual subscription of the same amount made it impossible for the working class to take advantage of the amenity. Covering such a large population, there were only 742 books available for loan.

Things have changed since that time with public libraries now available in most cities, towns and villages. In Aylesbury a new public library was opened in Walton Street in 2019, with a colourful, bright interior, a superb selection of books, and, of course, it's free to join.

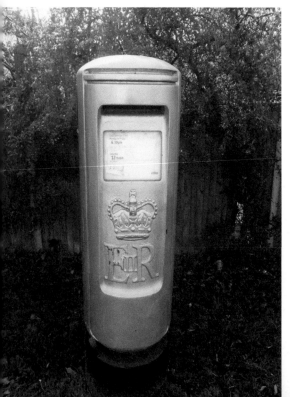

Above: Children's section of the public library, Walton Street.

Left: Gold-painted letterbox, Stoke Mandeville Hospital.

M

Market Square

The thriving and flourishing market first took place in the square in the thirteenth century. The town was situated at the centre of a road network ensuring that all visiting merchants would be required to regularly pay the expensively priced tolls of £10, which were unique in the county.

During the Middle Ages two fairs were held each year attracting people from all over the county, helping to build Aylesbury into a prosperous town. At one time there were six annual fairs including a hiring fair every October. Tradesmen in the market included nine specialist grocers and eight drapers, a stationer, brandy merchant, ironmonger and potash seller – the whole area being surrounded by slaughterhouses. Horse fairs were still being held up to the twentieth century.

A circular market house, with a gaol underneath, was used as an open covered market where traders would pay extra for their stalls. Law sessions and elections were also held here but the market house was demolished in the nineteenth century as permanent shops began to appear.

Early in the nineteenth century the town was ringed with extra tollgates and with money spent on improving the roads, more traffic and faster vehicles increased the

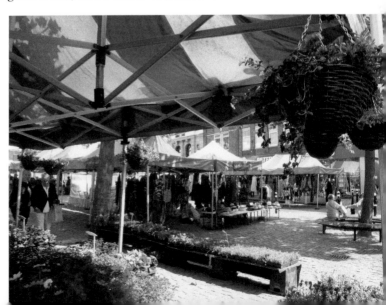

A colourful market day.

popularity of this trading centre. The town's stocks were positioned in the middle of Market Square and last used around 1840; later these were replaced by a clock tower, completed in 1877.

Originally the market was twice the size it is now with thirty-one inns recorded in 1577. By the 1870s there were an unbelievable eighty-seven inns in the town, many of which could be found in Market Square, including the White Hart, the Bell and the George.

Today the market, held four times a week and used for other special events, is still a thriving, busy place.

Minted Coins – And Tokens Too

Coins were minted here as far back as AD 978 during the reigns of Ethelred II, Cnut, and Edward the Confessor.

Tokens were also minted in 1796 when there was a shortage of coins. However this was possibly treated more as a piece of anti-slavery memorabilia than used for trading as they were minted in such small numbers.

Morgan, John – Immortalising the Burghers of Aylesbury

A well-known oil painting, *The Jury*, by the famous Victorian painter John Morgan hangs in the Bucks County Museum. His models were taken from the burghers of Aylesbury where he lived from 1860 after moving from Pentonville, London.

He worked on *The Jury* and *The Country Auction*, which shows the spire of St Mary's Church, whilst living locally but he suffered from ill health and moved around the country seeking places that would aid his recovery. Morgan regularly exhibited at the Royal Academy and the British Institution and was a member of the Society for British Artists.

His son, Frederick Morgan, was equally gifted, painting *His Turn Next*, a picture showing two children about to bathe a dog, which was used as an advertisement for Pears soap.

Museum

Bucks County Museum consists of a collection of intriguing historic buildings in the old part of town: the medieval guildhall and later courthouse; a large private house; and coach house and stables, now the Roald Dahl Children's Gallery. Also attached are the Georgian free grammar school and masters' houses, Latin school, Victorian and

Edwardian parish rooms, registrar's offices, and doctors' surgery, all combining to house this twenty-first-century museum.

The original guildhall was built around 1473 and housed the Fraternity of the Virgin Mary, a charitable organisation, which, when dissolved in 1547, was sold to a private family, possibly church lawyers.

It has been extended and modernised over the centuries and by 1866 it came into the hands of James Henry Ceely, who lived there with his brother, Dr Robert Ceely. The house, now named Ceely House, was a surgery and dispensary and you can still see the dispensing hatch in the museum shop.

In 1720 the new free grammar school opened, providing schooling for 120 boys. Both sides of the schoolhouse were the masters' houses, the smaller belonging to the Latin master and the main house, facing Church Street, was the headmaster's residence.

After purchasing the block of historic houses, the County Council opened the Aylesbury Gallery; however, significant restoration work was needed and the museum closed for six years. Bucks County Museum reopened in 1995 having spent £4 million on refurbishments and a year later was awarded Museum of the Year. In 2005 an enclosed glass 'garage' was added to house the 1922 Cubitt car, built in Aylesbury from 1919 until 1925.

Part of Buckinghamshire County Museum.

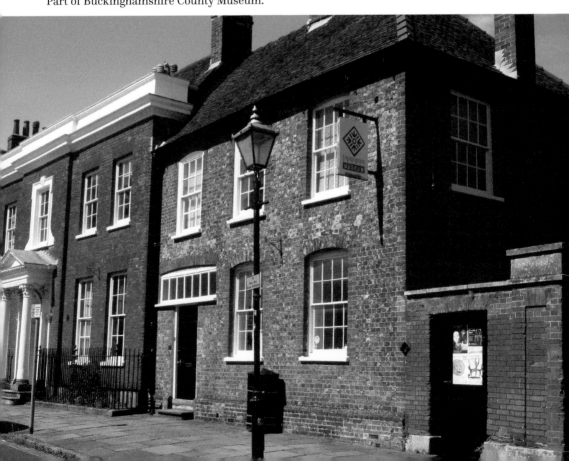

Nestle – A Surprising History

Nestle and the Second World War seem strange bedfellows but Nestle's help with injured servicemen is remarkable.

The arrival of the canal in 1814 and the railway in 1839 brought many new trades and industries to the town, one of which was the Aylesbury Condensed Milk Company. The factory was bought by the Nestle and Anglo-Swiss Condensed Milk Company in 1808 employing 150 workers, most of them female.

In 1943 the first penicillin production factory in the country was established in part of the Nestle factory in the High Street, where large quantities were prepared for the D-Day landings, thus saving many lives during the Second World War.

O

Osyth – Aylesbury's Patron Saint

The Vikings have a lot to answer for in history – some facts can be verified, others not so. St Osyth is said to have been murdered by the Danes and although her story has an element of truth, some of the facts may have been embroidered or exaggerated throughout the centuries.

Daughter of a king, Fredeswald, Osyth was born in her father's palace in Quarrendon and brought up in her aunt's nunnery. At a young age she made a vow of

Group of historical buildings now collectively known as St Osyth's.

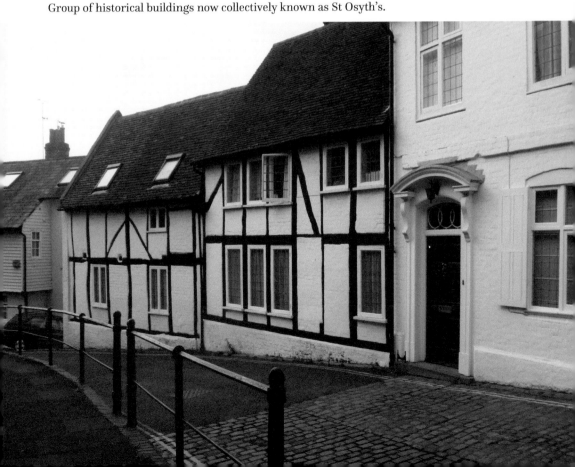

celibacy; however, her father forced her to marry at the age of thirteen. The marriage was not consummated. Osyth fled with her maids to the village of Chich in Essex where she founded a church and a nunnery, built by her husband, King Sibere.

It was at Chich where the Danes found her in around AD 665. The result of her refusal to worship their idols culminated in her being beheaded on 7 October. It is said that she walked to church holding her dismembered head in her hands, knocked at the door, and then died. According to legend a fountain of pure water 'gushed forth' from the spot. Later, the water was collected by monks to help cure the sick.

St Osyth's body was taken to Aylesbury, away from the Danes, where she lay in a tomb for forty-six years. This became a place of pilgrimage but it is uncertain as to where her remains are now kept. Some say her bones were buried in secret, others think she was returned to Chich, but there is also an account that her parents kept her in Aylesbury to be interred.

Her festival day is now 7 October where in Chich, now renamed St Osyth, it is said that her ghost appears carrying her head in her hands.

Parsons Fee

The cobbled street of Parsons Fee runs along the side of St Mary's Church in the old part of town. There was once a number of similar-sounding street names – Bawd's Fee, Castle Fee and Brand's Fee – but these have now disappeared.

The houses retain many of their attractive old timber-framed designs dating back to the seventeenth century with overhanging upper stories, which had the advantage of increasing the living space on a small plot of land.

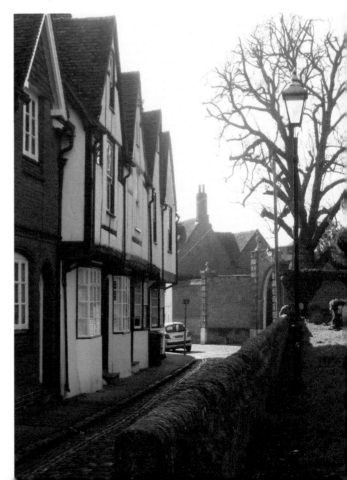

Parsons Fee, alongside St Mary's churchyard.

Pebble Lane.

Pebble Lane

A medieval lane leading to St Mary's Church was formerly called Church Row. Although its name has been changed, it still retains the original central drain which was added to enable the ladies of the town to walk to church without getting the hems of their long dresses wet.

Police

Similar to towns and cities all over the country, local policing was carried out by churchwardens and parish constables. However, these men were often unpaid, corrupt and were inept at keeping the peace.

Sir Robert Peel transformed the policing in London in 1829 by establishing the Metropolitan Police Service and by 1857 Aylesbury appointed its first paid and uniformed police officer, thereby creating a certain respectability to the town.

Section of the 'new' police station, Walton.

Population – Up and Up Again

Like Topsy or a Russian vine, Aylesbury keeps on growing at an unprecedented rate. In the early sixteenth century it was a prosperous large village of between 800 to 1,000 inhabitants, a higher number of residents than most market towns. A century later the population had doubled despite outbreaks of the plague in 1603 and 1665. The earliest Black Death records show that in 1349 at least eighty-seven members of the parochial clergy died from the infection.

By the early 1700s the town had approximately 400 houses, which constituted a large town. Not only was it growing in population but also in trade with a stagecoach leaving for London every day.

As the Industrial Revolution took hold farmers and other villagers from the surrounding countryside descended on the town. Farming machinery and the rapid decline in the lace trade in the 1820s both took their toll.

Housing was in short supply. In 1831 the total number of inhabitants rose by 408 while the number of houses increased by only seventy-five. Many people suffered hardship, and life expectancy dropped to twenty-eight years. One child in every seven died before reaching their first birthday. Aylesbury was one of the first towns to have a public enquiry under the new Health of Towns Act 1848, held in December of that year. In 1851 there were 534 deaths recorded, 204 of which were under five years old.

From a population of just over 3,000 in 1800, a century later the number of residents had tripled. Terraced rows of houses were built to accommodate as many people as possible into the already overcrowded town. This idea has since been interpreted into a more stylish Serpentine-shaped building comprising of ninety-four houses and

Below left: Aylesbury from above. (Image supplied by Wendy Turner)

Below right: Contemporary sculpture in The Exchange.

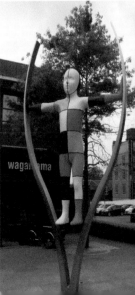

flats over three floors – as you can see in the purple and yellow snake-like building in the centre of the photograph.

A more recent surge in numbers occurred in 1959 when the borough council agreed with London County Council to become an overspill town. With Aylesbury already reaching almost 29,000, drastic action was needed. Controversially, large sections of the old town surrounding Market Square were demolished for redevelopment, although thankfully much of the historic interest around St Mary's Church still survives.

The Exchange, a new modern pedestrian square, was opened in March 2019 complete with contemporary sculptures by the artist Colin Spofforth. As well as restaurants and easily accessible open spaces, new small number of houses are also being developed along with much bigger plans for the whole of Aylesbury leading up to 2033.

Prebendal House

This large imposing house, lying south-west to St Mary's Church, was one of the town's manors owned by Lincoln Cathedral, thereby giving them the right to collect tithes. Those farming on the manor's land paid a tenth of their harvest to the cathedral.

From 1749 to 1764 the house was owned by the controversial Member of Parliament John Wilkes, who obtained the estate by his marriage, which he managed to retain after later separating from his wife.

Gateway to Prebendal House.

Printing – A Community to be Proud Of

A major firm providing work and social amenities for 900 people in the late nineteenth and early twentieth century was the printing company Hazell and Watson. They first opened in 1867 and moved into much larger purpose-built premises in 1878 when they became Hazell, Watson and Viney, printing publications for Penguin Books, Hamlyn and Reader's Digest.

Other printing presses followed and by 1939 almost one third of the town's population worked in this industry. Apart from other smaller printing firms, Hunt Barnard was the second largest, printing books, magazines and catalogues.

However, it was Hazell, Watson and Viney who held the key to job satisfaction by providing houses for some of their employees including a provision of 22 acres of allotments, a social and sports club, the town's brass band and a volunteer fire brigade complete with their own fire engine. The Reader's Digest print run took three weeks every month to complete, the machines overheating so often that their fire brigade was on constant alert.

Although no longer in use, the fire engine has been restored and is a great feature at local vintage rallies.

Below left: Original printing press, Bucks County Museum.

Below right: Fire engine from Hazell, Watson and Viney.

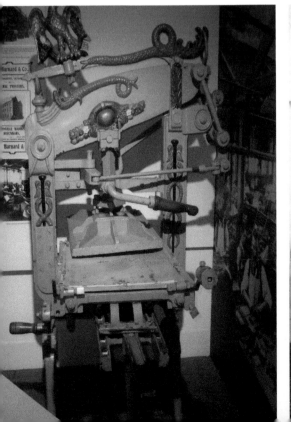

Quainton Windmill – Highlighting the Village

The final elements have now been completed for the restoration of this family-owned windmill, which has lain derelict for most of the last century. It was built in 1832 by James Anstiss, milling grain by wind until 1890 and then under steam until around 1914.

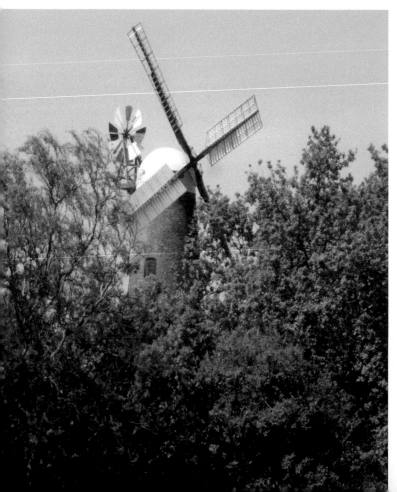

Restored Quainton windmill with full sails.

It began to deteriorate until a group of voluntary local enthusiasts headed by Nick Anstiss set about repairing and rebuilding the six-storey brick windmill. Standing at 70 feet tall, it dominates the skyline and is the third tallest windmill in England.

Quaker Meeting House – A Full Circle

Although the Quakers' premises in Rickfords Hill dates from 1727, it has only just been listed. The Meeting House offers great architectural and historical interest and boasts a chequered past life. Built originally as a Friends Meeting House, double shutters were erected in the meeting room in 1810, presumably for use as a separate women's meeting area.

Records show that in 1829 there were approximately 600 nonconformists in the town and only one solitary Quaker. Sometime later the building was converted into an infants' school followed by use as a Baptist chapel. Further changes were then made for the YMCA, who used the building until in 1933 it was refurbished and finally returned to the Quakers.

The small garden at the rear contains a burial ground, the first burial taking place in 1727.

Quaker Meeting House, Rickfords Hill.

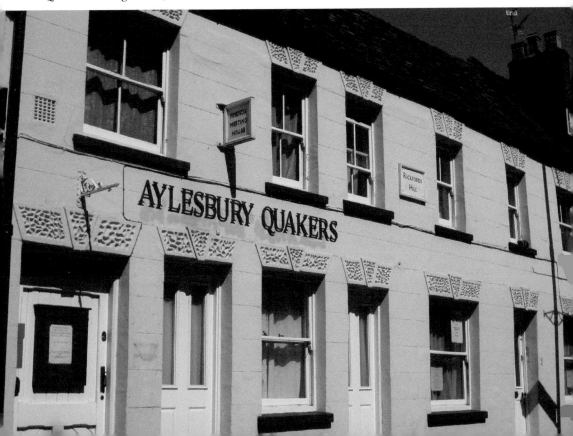

The Friends garden, once a burial ground.

Quarrendon Leas – Preserved for the Town

Twenty people and 300 pigs was the total inhabitants of this Saxon village, but like most ancient villages, Quarrendon has repeatedly fallen into disrepair and then been built upon, and by the sixteenth century the pigs had been exchanged for rabbits.

Although the village was here before the Norman Conquest, the first recorded redeveloper on this site was Sir Henry Lee, building a large moated mansion together with a water garden encompassed by high walkways and an elaborate rabbit warren. This covered much of the original village, leaving only the local church, St Peter's, intact.

Sir Henry was one of the favourites of Queen Elizabeth I and it is said that he entertained the Queen here in 1592. Sir Henry may have been an excellent host but his financial abilities were less so – he went bankrupt. The mansion and gardens became derelict but luckily the ruins were not built over. A farm replaced the mansion with grassland for grazing sheep covering most of the area for the last three centuries. Although the farm was demolished in the 1970s, it was found that an outline of the original mansion and gardens still remained.

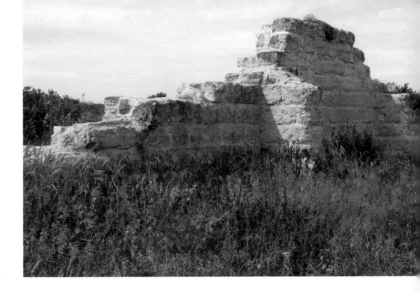

Ruins of St Peter's
Church, Quarrendon.

Quarrendon Leas is now a suburb of the main town but part of this historic area has been carefully preserved. Visitors can see a section of the ruined church of St Peter's consisting of one of the south aisle buttresses and two lower sections of a wall. A water-filled moat which once surrounded Sir Henry Lee's mansion is still in existence, but unfortunately everything else has been lost. Hopefully, along with the sheep, descendants from the original rabbit warren are still living here.

Quarry Slate Pencils – And the Original Pencil Sharpener

Before the use of pens and paper schoolchildren used wooden-framed slate boards and slate pencils with which to write. The boards could be wiped clean with a damp cloth and used again – hence the saying 'to wipe the slate clean' meaning to start again.

The slate pencils needed constant sharpening and children attending the local school would make deep indentations in the brickwork with their 'pencils' outside the main school door.

Deep indentations from slate pencils.

Railway – First Branch Line in the World

Boasting the world's first branch line in 1839, the main London and Birmingham railway completely changed the economy of the town. As well as helping small businesses to flourish, larger industries began to arrive along with wealthy visitors from London keen to take part in the fashionable sport of hunting with hounds.

A further advancement was the second railway, the Great Western, in 1863, which also added to the town's prosperity, one of its imaginative promotions being the sale of cheap market tickets on market days.

Railway station, Station Way West.

Rickford, William – Founder of the Aylesbury Old Bank

As trade grew in the town so there was a need for a bank. The Aylesbury Old Bank standing on the corner of Market Square and Kingsbury Square was established as early as 1795, when there were very few banks in and around the whole area of Aylesbury Vale.

William Rickford inherited the bank from his father, a former grocer, and ran the business from 1803 until he died in 1854. The bank was later renamed the Oxon and Bucks and is now Lloyds Bank.

As well as finance Rickford was also interested in politics and stood as an MP from 1818 to 1841. He was a Whig campaigning in favour of the Reform Act of 1832, which reformed parliament but made a point of refusing women and the majority of working-class men the vote.

Rickford lived in Green End House, Pitches Hill, since renamed Rickfords Hill.

The Aylesbury Old Bank, corner of Market Square and Kingsbury Square.

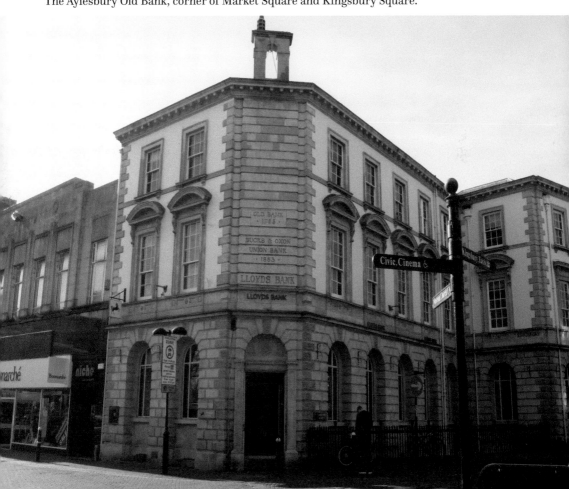

Roald Dahl Children's Gallery – To Enjoy and Inspire

'Boredom is a curse' was a belief held by this much-loved author who not only wrote novels but was also well known for his short stories and poems. Even his own early history reads like an adventure story – he was a fighter pilot *and* a spy during the

Above: Open doors to the Roald Dahl Children's Gallery.

Left: The Giant Peach. (By kind permission of Bucks County Museum)

Second World War. However, he is best known for his children's books, selling more than 250 million worldwide.

At the gallery, which is attached to the Bucks County Museum, children can explore his books and characters with larger-than-life images. The gallery has won two major awards for education, almost guaranteeing that here children will never be cursed with boredom!

Royal Buckinghamshire Hospital – Honoured for Its Services

The Prince of Wales, later to become King Edward VII, granted the added title of Royal to the Buckinghamshire Infirmary when he was treated there after breaking his leg. Dr Robert Ceely, of Ceely House, helped to establish the Infirmary in 1833.

The hospital was rebuilt and completed in 1862 with advice from Florence Nightingale. It had the honour of being renamed the Royal Buckinghamshire Hospital as part of Queen Victoria's Golden Jubilee celebrations and is now a private hospital for those with spinal and neurological conditions.

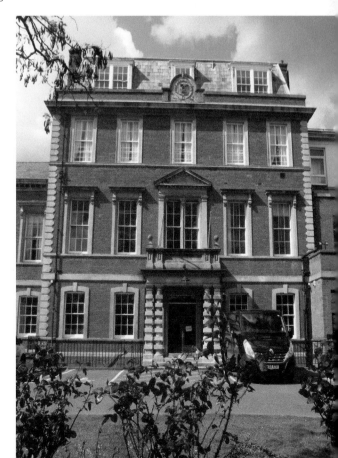

Royal Buckinghamshire Hospital.

Sheriffs of Buckingham – A Pin Seals the Deal

A strange ritual began when Queen Elizabeth I chose the next sheriffs in the country by sticking a needle next to the name of the annual selections. She was in her garden when presented with the list, and having no pen to hand she pierced the parchment with her sewing needle. The romantic tale is somewhat spoiled by evidence that this ritual was carried out previously by Henry VIII. However, this system is still used today when the Head of State pricks the roll of parchment with a silver bodkin.

Each county holds a Declaration Ceremony where the outgoing High Sheriff hands over his office to the new incumbent. This ceremony is always held in the County Court in Aylesbury for the Sheriffs of Buckingham.

Dating back to before the Norman Conquest, their duties included keeping the peace, collecting taxes and rents for the king, and being responsible for the local militia. Today their roles include carrying out numerous ceremonial functions as well as attending any royal visits to the county, acting as returning officer for elections, and giving their support to voluntary and statutory organisations including the police and the probation and prison services.

Silk Industry

A silk manufactory solely to employ the poor was opened by Robert Nixon, a silk manufacturer from Manchester. Built on similar lines to one already in existence in Tring, the business proved so popular that before long there were forty looms in operation providing work for many of those in need living in the town and surrounding areas.

St Mary the Virgin Church – High Point of the Town

There is no cathedral in Aylesbury even though it is the county town of Buckinghamshire; however, the parish church of St Mary the Virgin amply makes up for any missing status. This lovely old church has suffered from the inadequate funds that it truly deserves. Over the centuries it has spent much of its life being propped up in one area or another in a rather undignified manner with a make-do-and-mend philosophy.

The original church appeared on this hill site sometime between 637 and 1200 and was mentioned in the Doomsday Book in 1086. The church was rebuilt at least three times during this period.

The famous Aylesbury font was made towards the end of the twelfth century but it wasn't until the middle of the next century that St Mary's Church was finally completed. It now boasts being the oldest surviving building in the town.

Two extensions were constructed, now called Lady Chapel and St George's Chapel, and at a later date the clerestory, sacristy and the priest's chamber were added as well as repairing much of the roof. Beneath the Lady Chapel is a crypt containing Saxon brickwork, which possibly dates from when the town was a Saxon settlement around 571.

Until the middle of the sixteenth century the walls would have been covered in paintings but the sacrilegious decision was made to cover them in white paint. It was after this act that the church began to collapse. The south-west arches were the first section to be blocked up followed by arches in the north-west. A couple of decades later the south-east and north-east arches were walled up as the building continued to crumble.

Sadly, other destructive forces invaded St Mary's Church. During the English Civil War the Parliamentarian soldiers broke into the building and destroyed the beautiful stained-glass windows, smashed all the monuments and set fire to some of the furniture. Nothing remains in the church from before this time except the stone font.

Surveyors have come and gone, reports have been given regarding the church's unsafe condition and the need for re-erection, and funds have been sought without success. By the time the nineteenth century arrived the foundations were weakened and the building was found to be in a dangerous condition.

In 1848 a London surveyor reported that, with luck, the church might still be standing by the time he got home. That same month, during a Sunday morning service, there was a loud crashing noise heard from above. The congregation, fearing that the surveyor's words were coming true, panicked to escape from the danger. They stood in the churchyard and watched. Nothing happened. A few ventured back inside. Still nothing happened. The remaining congregation plucked up courage, resumed their

seats and the service continued. Later it was discovered that the fastening which held the bells had given way. For once the church was not collapsing.

More reports were made, money was raised and borrowed, the church was closed for repairs and the services were moved to the County Hall. Two years later the church was reopened but it was by no means finished. Much of the interior still had to be improved and the exterior was yet another major restoration to be tackled.

The Norman font was rescued along with a carved table and iron chest, a rare oak vestment press and some of the stained-glass windows. The perpendicular west window made with colourful Victorian glass and showing Old Testament scenes, prophets and other characters was awarded a medal at an international exhibition in 1863.

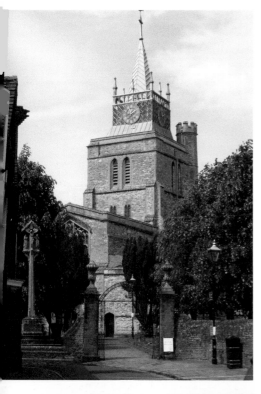

Left: St Mary the Virgin Church.

Below left: Wooden carved pulpit, St Mary's Church.

Below right: Award-winning stained-glass window, St Mary's Church.

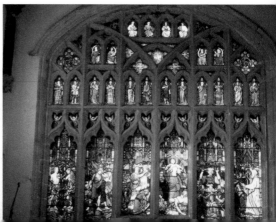

By 1869 the restoration work had cost £16,000. Many beautiful features had been removed: the intricately carved manorial pew, the three-decker pulpit and the original east window, which found a home in the garden at Green End House in Rickfords Hill.

A cheer must have resounded from the congregation when as late as 1960 electricity and heating was finally installed.

St Mary's Church has changed over the years and has adapted to the needs of its wider congregation. To address modern-day challenges, it is now a dual-purpose building for both religious and social activities. However, this idea is nothing new. Adding to its lively history it once housed the town's fire engine, firefighting items, grave-digging and funeral equipment. During the Napoleonic Wars it even stocked the gunpowder required for the local regiment.

Like many ancient buildings it still needs financial help. A further major restoration programme is now being planned, which could cost over £10 million. This is Aylesbury's 'cathedral'; its history can obviously match that of any true cathedral and St Mary's Church certainly deserves to be restored to its full glory.

Stoke Mandeville Hospital

The National Spinal Injuries Centre at Stoke Mandeville Hospital is the oldest and one of the largest centres in the world with a superb national and international reputation.

It was founded in 1944 by Sir Ludwig Guttmann who realised that soldiers suffering from spinal injuries in the Second World War showed tremendous signs of improvement when they were encouraged to take part in sporting activities.

Severe weather in 1980 was responsible for much structural damage to the wards. Unfortunately, the area health authority had no funds with which to help in

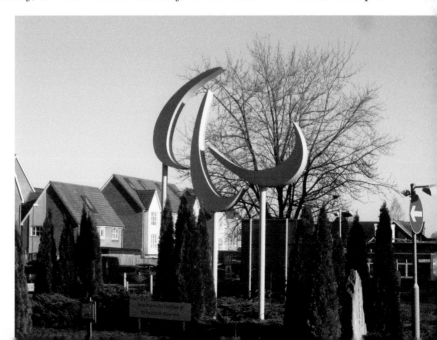

Three Agitos, the Paralympic symbol from the Latin meaning 'I move'.

Horatio's garden, Stoke Mandeville Hospital.

any rebuild. Massive fundraising was organised in the hope of having a purpose-built centre. With the public's generosity £10 million was raised in only three years. It was reopened in 1983.

An Horatio's garden has since been designed, created by Joe Swift – a RHS gold medal winner and presenter of BBC's *Gardeners' World* – to encourage patients to grow their own vegetables and eat them!

Straw Plaiting

Along with lacemaking, straw plaiting was also a popular cottage industry from the beginning of the nineteenth century. Women and children could earn between seven to thirty shillings a week to supplement the wages of the menfolk who worked as agricultural labourers.

The plaited straw was used to make bonnets and hats and such was the demand that according to an 1871 census there were approximately 30,000 full-time people working in this trade in and around the town as well as many part-time and casual workers.

T

Talking Newspapers

A dedicated band of volunteers meet once a week at the Methodist Church Community Centre to record stories, articles and news from the local *Bucks Herald* newspaper for blind and visually impaired people.

This national service was first discovered in Sweden, first produced in Wales and now consists of over 500 groups in the UK with more than 60,000 listeners. The Aylesbury Lions Club first began this service in the early 1980s and Alan Drake, a former member of The Lions, is now the chairman of the Talking Newspapers and has been running the group for almost forty years.

The readings were initially recorded onto tapes, which could hold between sixty to ninety minutes. With the advent of new technology, the volunteers now send out weekly memory sticks that can hold up to six hours of information, providing a vital link to those who wish to be informed of everything that is happening in their town.

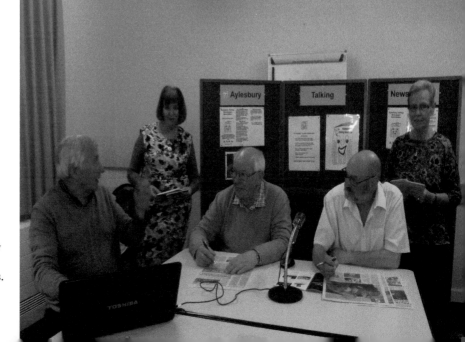

Alan Drake (left) with volunteers at Aylesbury Talking Newspapers.

Tiggywinkles – Wildlife Hospital Trust in Action

Facilities for the care of injured wildlife was seriously lacking in this country until Sue and Les Stocker and their son, Colin, decided to look after casualties in their home. Word soon spread of their care but it was not only the general public who sought out their help – wildlife welfare societies also began to use their services.

The difficulties in learning about the care needed for different breeds of animals and birds soon became apparent, but with the help of a local vet they began to learn the intricacies of the different wildlife they were caring for. All this work was carried out in their own home funded by their own savings, but the workload increased to such an extent that in 1983 they decided to become a registered charity by the name of the Wildlife Hospital Trust.

Two years later a new shed was built to house the world's first hedgehog unit, which was opened by the actor Susan Hampshire, and named Tiggywinkles. The project was almost forced upon them by the sudden influx of hedgehogs needing care during the drought of 1984. A nationwide campaign was set up to ask members of the public to put out dog food and water to help save the hedgehogs and to warn people against the popular idea that hedgehogs needed bread and milk – a dangerous combination.

The veterinary team at the hospital consists of trained veterinary nurses and specialist consultant veterinary surgeons. The information gained and their knowledge on the care of all species of wildlife has spread throughout the world via published books, papers, courses and lectures at veterinary schools.

Not all casualties survive but those who are unable to be released back into the wild are cared for at the hospital in an environment as close to their habitat as is possible. Over 200,000 injured wildlife have been through the doors of the Trust, where they have received care and treatment with the specialist knowledge of the team, all thanks to the small beginnings and compassion of the Stocker family.

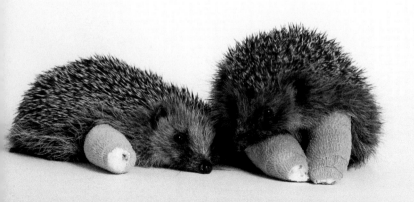

Two patients at the Wildlife Hospital. (© Les Stocker/ Tiggywinkles)

U

University Campus – Where There's a Will...

There was an upside to paying tax on beer and spirits in 1891 – it helped to fund the local university! From this unorthodox beginning where the school was able to provide evening classes in science and art for the local people it has grown beyond

University Campus Aylesbury Vale, Walton Street.

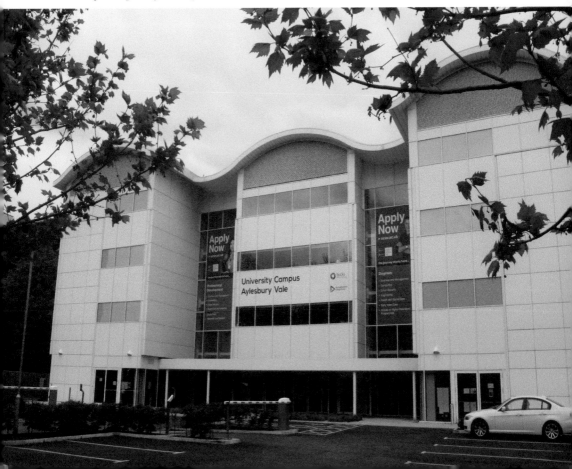

recognition. After the First World War soldiers were sent here to learn skills to enable them to find work in a country that had been left suffering with mass unemployment.

The school has always maintained strong links with local employers and businesses. Concentrating on vocational learning has led them to teach cabinetry and other furniture carpentry, their proven success being in the 1960s when around 80 per cent of the country's wooden chairs would have come via the school.

In 1999 they were awarded University College status and it is now known as Buckinghamshire New University, where over £100 million has been invested over its three campuses.

Famous alumni are Noel Fielding, the comedian who co-hosted The Great British Bake Off, studying graphic design and advertising; Naomi Riches, an adaptive rower who won bronze at the 2008 and gold at the 2012 Summer Paralympics, studying designed metalwork and jewellery; and Chloe Rogers, the hockey player who won bronze also at the 2012 London Olympics.

The university is no longer funded from beer and spirit taxes – although perhaps it still may be in one way or another!

Upper Hundreds Way

Groups of 100 men would be responsible for law and order in the town in the seventh century. These men were divided into smaller units of ten, were obliged to oversee the good conduct of the townsfolk in their patch and ensure that anyone charged with a misdemeanour attend court.

Upper Hundreds Way is named after this slice of history and runs between Cambridge Street and Vale Park Road.

V

Vale Park

The original marshy and unhealthy area just below the hill of the town has now become Aylesbury's fragrant central park with a Green Flag award.

In the late 1880s it was used as a cricket ground complete with a pavilion. Four decades later plans were put forward by the British garden designer, landscape architect and town planner Thomas Hayton Mawson. The final plans were submitted by his eldest son, Edward Prentice Mawson, who had taken over much of the work when his father began to suffer from the effects of Parkinson's disease.

Despite the fact that father and son had worked on the Peace Palace in The Hague and the palace gardens in Athens – although perhaps that should have been a clue for the Borough Council – the execution of the plans would have proved to be too expensive. They were reworked by the council and the park is now a hub of activity, especially in the summer when live music is played on two stages during the August Bank Holiday Parklife weekend.

More permanent amenities include the Aqua Vale swimming pool and café, with tarmacked areas for football and basketball, tennis courts, and a purpose-built skate park.

Below left: Springtime in Vale Park.

Below right: Water fountain from Kingsbury Square, Vale Park.

War Memorials

Three notable war memorials are to be found in Market Square, St Mary's churchyard, and in the Chapel of St George.

The official policy of not repatriating the dead after the First World War led to an influx of war memorials in most towns, villages and cities. An architect from Aylesbury, Mr F. Taylor, adapted the Cross of Sacrifice, originally designed by Reginald Blomfield, into a memorial in the town centre, which was paid for by public subscription. The majority of the labour was undertaken by ex-servicemen in honour of the 300 members of the local community who had died.

Unfortunately, Reginald Blomfield was unimpressed by the adaption, stating 'there is a deplorable example ... in the market-place at Aylesbury. The local man has done his best, but he has simply murdered my Cross.'

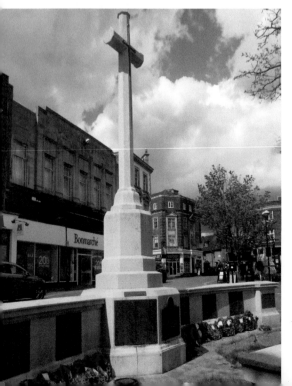

War memorial, Market Square.

Right: Lowered section of wall to accommodate the war memorial, St Mary's churchyard.

Below: Misdated plinth on war memorial, St Mary's churchyard.

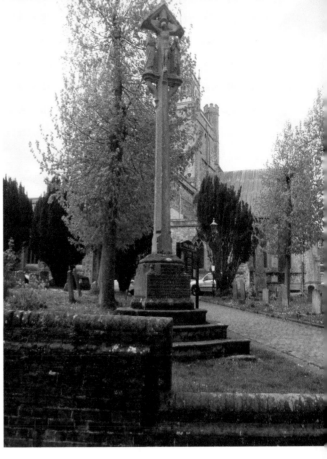

The memorial was rededicated at the end of the Second World War and plaques were added to record the names of the dead with an additional plaque commemorating Simon Cockton, who was shot down by 'friendly fire' over the Falkland Islands in 1982.

A further memorial was erected at the end of the First World War in St Mary's churchyard depicting an elaborate Calvary cross. After the ceremony it was found that part of the churchyard wall had to be lowered so that the cross could be seen from the street. This was not their only error. The bottom of the monument shows the wrong date for the ending of the First World War. Unusually the memorial has not been adapted to include those fallen in the Second World War.

Inside St Mary's Church can be found the third war memorial where the Chapel of St George was restored by the Bucks Battalion of the County Regiment as a memorial 'to the fallen of both world wars'.

Water Pump

An 1840s water pump graces the old brick wall in Pebble Lane where the town's residents came to collect their drinking water. The pump was situated at a convenient height for use by water carts, which would be filled and used to lay the dust on the roads.

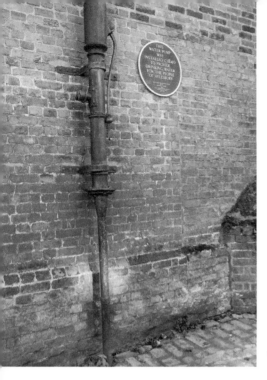

Water pump, Pebble Lane.

Waterside Theatre

Designed to replicate the rolling Chilterns Hills, the Waterside Theatre is an impressive-looking building. At a cost of £47 million, it was destined to open in grand style. In 2009 the actress Lynda Bellingham, hailing from Aylesbury, completed the highest point of the building with a topping-out ceremony – a traditional builders' rite that marks the ending of the building work.

A year later it was the turn of further celebrities: Cilla Black formally opened the theatre and the occasion was marked with an open-air live event hosted by Jonathan

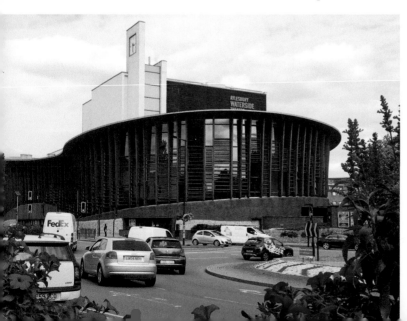

Waterside Theatre, Exchange Street.

Wilkes and Suzanne Shaw. Guests included David Suchet, Simon Callow, Ruby Wax, Susan Hampshire and Richard O'Brien.

With a 1,085-seat auditorium, the theatre has a diverse range of entertainment on offer including West End and touring musicals and plays, opera, ballet, children's shows and Christmas pantomimes.

The Waterside Theatre is set to continue the highly respected reputation Aylesbury already has in the entertainment business.

WhizzFizzFest

Taking Roald Dahl as their inspiration, the annual WhizzFizzFest is a literary and arts festival held every summer throughout the streets of the town. Popular children's authors and other artists are invited to take part with stories and talks for all ages. Children dressing up as Dahl's characters with giant sweets and enormous puppets join in the parade.

Wilkes, John– Campaigner for Liberty and Freedom of the Press

There have been many colourful Members of Parliament over the centuries but John Wilkes could be considered the most scandalous and roguish of them all. Jeremy Paxman once said of him, 'I like John Wilkes because he was a wonderful and odious man – which is a rare combination.'

Wilkes was elected MP for Aylesbury in 1757, achieved by appointing his agent, John Dell, as one of the returning officers whose convenient responsibilities included counting the votes. Approximately three-quarters of the votes had already been paid for with bribes varying between £1 and £5, and an increased sum of a guinea (£1.05p in modern money) paid to 250 mercenaries. This was common practice in other parts of the country, although Wilkes' total bill for bribes was said to have cost him a massive £7,000.

The opposition party led by Edward Willes withdrew from the by-election, paving the way for John Wilkes to take his seat in the House of Commons. He was regarded as a poor orator and it took him four years to make his uninspired maiden speech in support of William Pitt, who was keen to take up arms against Spain.

Wilkes was already a popular figure in the town. He held respectable positions in the community including High Sheriff of Buckinghamshire, Justice of the Peace, churchwarden, and trustee of both the local grammar school and the turnpike.

He had entered into an arranged marriage with Mary Mead in 1747. She was ten years older than Wilkes, the daughter of a wealthy widow. Three years later she gave

birth to a daughter, although Wilkes went on to father five further children outside his marriage. His personal life began to suffer. The marriage lasted only ten years with Wilkes keeping his wife's dowry of the manor in Aylesbury and the custody of their daughter, agreeing to pay his wife £200 a year.

He was a notorious womaniser and preferred to spend his time at the Hell Fire Club and the Sublime Society of Beef Steaks. With his crossed eyes and protruding jaw, he was unfortunately described as the ugliest man in England but was said to have the advantage of being witty and charming. He was famous for boasting that it 'took him only half an hour to talk away his face'. When the Earl of Sandwich told Wilkes that he would die either on the scaffold or of the pox, he retorted with the famous put-down, 'That must depend on whether I embrace your lordship's principles or your mistress.'

By 1762 George III had ascended the throne with the unpopular decision of making his friend, Earl of Bute, Prime Minister. Many of the Members of the House disagreed with this appointment and leading the attack on the King and his Prime Minister was the MP for Aylesbury, John Wilkes.

Although a poor public speaker, he was an excellent outspoken journalist. He published a political newspaper, the *North Briton*, with which to discredit his two adversaries, stating in his first issue that 'the liberty of the press is the birth-right of a Briton...' and in a later issue commenting on the king's speech at the opening of Parliament as '(giving) his sacred name to the most odious measures...' He also had the audacity to intimate libellous innuendos between Bute and George III's mother.

It didn't take long for Wilkes to be prosecuted for libel for printing 'a treasonable paper'. A general warrant was issued and forty-eight men were arrested in search of evidence. Later, Wilkes was arrested and sent to the Tower of London. Within a week he was released – his arrest had been considered a breach of parliamentary privilege. From this Wilkes was able to establish the illegality of general warrants prohibiting non-specific arrest warrants.

He continued his attacks on the king and the government. In 1763 he was challenged to a duel by Samuel Martin, a supporter of the king whom he had called 'the most treacherous, base, selfish, mean, abject, low-lived and dirty fellow that ever wriggled himself into a secretaryship'.

On 16 November 1763 Wilkes was shot in the stomach. Badly injured, his friends took him to Paris for safety and after living under an assumed name Wilkes eventually applied to stand for the Middlesex constituency back in England. He went on to be imprisoned yet again and banished from the House of Commons, although strangely he was elected Lord Mayor of London.

He is remembered locally as it was in Aylesbury where his political career began, and he is celebrated countrywide for being an advocate of free press, forcing the government to allow newspapers to publish full accounts of parliamentary debates.

It is uncharacteristic of the town not to have erected a statue in his honour. The only tenuous link to him apart from Prebendal House is a commemorative plaque in the wall between the house and St Mary's churchyard where Wilkes placed a

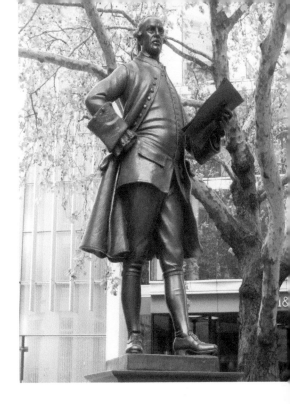

John Wilkes statue, New Fetter Lane, London.

tribute to his gardener. It reads: To the memory of John Smart Gardener who died the 16th day of Novr' 1754 aged 54 years. *Illum etiam lauri illum etiam flevere myricae. Virg.'* The Latin translates as 'even the laurel and the myrtle wept for him'. Perhaps this is even more fitting than a statue considering his less than glamourous looks. It shows that beneath the roguish showman exterior lay a spirit of empathy to the underdog in society.

Workhouses

Up to ninety men, women and children were crammed into the workhouse on the corner of St Mary's Square and Pebble Lane in 1777. However bad this was for the residents, previous centuries had shown conditions for the poor to be far worse. By 1572 towns and parishes were made responsible for building almshouses and local taxes were made to pay for flax, wood and hemp to help the poor earn a meagre wage making rope, and at a later date, lace.

Accommodation in almshouses, or workhouses as they became known, was available providing the poor wore badges of red or blue cloth with the letter P and the first letter of the parish on their clothing. Those refusing to do so or caught without their badge would be punished with whipping or twenty-one days' labour, with all parish relief withheld.

By 1829 further overcrowding at St Mary's Square became such an issue that another workhouse was built on a 2-acre site next to Mill Close, belonging to Mr Rickford, at a cost of £3,500.

Entrance to Tindal House, Bierton Road.

In 1834 Prime Minister Earl Grey brought in the Poor Law Amendment Act, which stipulated that towns be responsible for many more poor people living in the surrounding areas as well as those living locally. Parishes were grouped into unions and each union had to build a workhouse of adequate size. An even larger workhouse was planned to be built in Bierton Road at a cost of £7,350. This new law encompassed all forty parishes in the area and the Aylesbury Union was formed to oversee the operation.

Designed to resemble a Tudor manor house with bay windows and tall elaborate chimneys, passing vagrants were allowed only one night's refuge before being sent away. In later years the workhouse was renamed the Aylesbury Poor Law Institution, and later still as Tindal Hospital. The system changed completely in 1947 with the National Assistance Act, and the Tindal Centre, still a caring organisation, has become a hospital for those suffering from mental illness.

Wyatt, James

For over twenty years James Wyatt drove the *Dispatch* coach from Aylesbury to London, from 1816 to 1837. It was the first coach to perform the journey in a single day but with the advent of the new local railway line, stagecoaches became redundant and so, unfortunately, did James Wyatt.

Xmas at Waddesdon Manor

James and Dorothy Rothschild inherited Waddesdon Manor in 1922. As was the custom, each Christmas they gave presents to their tenants and servants. Mr Sims, the farm bailiff, was given the task of supplying a list of preferred poultry for all the recipients – one list was headed 'Myself - a goose'.

The estate, bequeathed to the National Trust, first opened its festive doors to the public in 2003. They have been putting their Christmas decorators to task each year to devise new arrangements, Christmas tree designs, and imaginative lighting.

The work begins at the end of October when the main house is closed for cleaning, maintenance and repairs. A few weeks later, from the middle of November until the New Year, the East Wing is reopened amongst a glitter of selectively designed ceiling-height Christmas trees and wall and ceiling decorations. Oozing charm and sophistication, it is opulence at its very best.

Decorated tree stumps. Aviary gardens light trail, Christmas at Waddesdon Manor. (© National Trust, Waddesdon Manor. Hugh Mothersole)

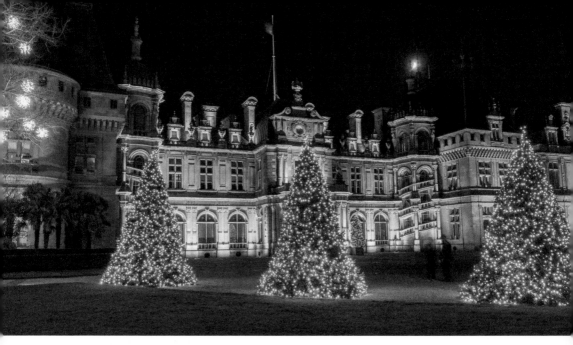

Above: Manor illuminated, Christmas at Waddesdon Manor. (© National Trust, Waddesdon Manor. Photo Hugh Mothersole (5))

Below: Trees lit up for the season. Aviary gardens light trail, Christmas at Waddesdon Manor. (© Yes Events Ltd (14))

The event is completed with a popular Christmas Fair held in the grounds selling an abundance of unusual gifts, but the highlight has to be the contemporary and traditional light installations in the gardens and around the aviary, all of which is accompanied by a magical sound system.

Y

Young Offenders Institution

The Victorian county prison has been in Aylesbury since 1847, originally modelled on Reading County Gaol and able to accommodate up to 285 prisoners. By the 1980s it had changed into a women's prison and after building two additional wings it housed those belonging to the suffragette movement charged with militancy. Suffragette Violet Bland was force-fed in 1912 and when released wrote a book entitled *Votes for Women* recounting her prison experiences.

Young Offenders Institution, Bierton Road.

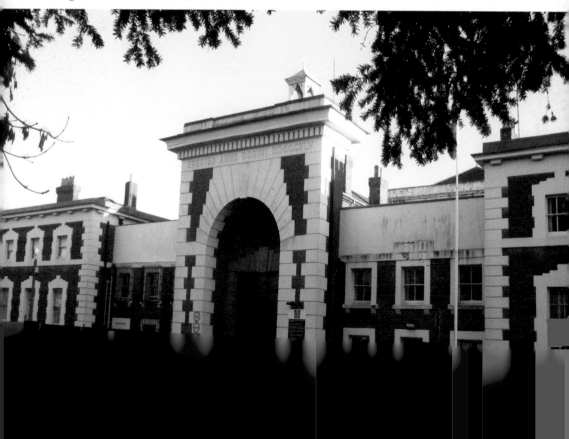

Changing its intake yet again, the prison became a girls' borstal in 1930. During the Second World War Mathilde Carre, a French Resistance worker who turned double-agent, was held here during the last years of the war where she became an informant against other prisoners. She was later deported back to France.

After yet another conversion for adult male prisoners, it has now become a Young Male Offenders Institution and can hold up to 444 prisoners in its seven residential wings, comprising of single and double cells. Prisoners are aged from eighteen to twenty-one and have long-term sentences from four years to life imprisonment.

An extensive range of activities are provided from construction work to cookery with many subjects offering NVQ Level 2 diplomas or the equivalent, including the Duke of Edinburgh award scheme.

Z

Zebedee and Zachary

Alpacas are gentle and inquisitive creatures with soft fleece and long-haired, spiky top nots. They are a member of the camelid species, closely related to the llama with a similar but almost comical look about them.

Alpacas were first introduced into this country from Chile in the nineteenth century mainly for zoos, but their popularity has grown and they are now in great demand. These animals are also bred in Peru; however as their popularity grew in Europe, Peru was exporting its good stock, and so the sale of alpacas abroad was halted.

Liz Barlow bought her original breeding stock from Chile – two pregnant females and then five more of Chilean origin. The original two females gave birth to two males, Zebedee and Zachary, who were the first two cria (baby) alpacas to be born just outside Aylesbury in 1999.

Liz was one of the first alpaca judges to be selected in the country and is a judge at national level as well as being asked to judge all over Europe. The national alpaca show is held annually in the Exhibition Centre in Telford, where numbers are limited to 600 entrants. She judges both types of alpacas: Suri, which have long flowing fleece used for larger outer garments like coats, etc.; and Huacaya (pronounced wa-ky-ya), which Liz breeds, with shorter fleece that is mainly made into knitted goods such as socks, gloves, scarves and cardigans. Their short fleece grows in bundles with a crimped wave giving them the appearance of a teddy bear.

Fleece coats were very popular amongst the well-to-do in Victorian times and although Queen Victoria was given two alpacas, one white and one black, there is no record of her receiving them. An alpaca coat today would cost from £300 to £500.

Many are bred for their luxurious fleece. They are sheared once a year from May to early June but their top knot is trimmed throughout the year. This longer fleece on the top of their head saves them suffering from sunstroke and also helps to keep the flies out of their eyes.

'There are twenty-two natural colours of alpacas,' explained Liz, with a colour chart ranging from white through to varying shades of brown to black, and also from greys through to rose-browns.

Young alpaca from Liz Barlow's stock.

These endearing animals live for approximately twenty years, eating mainly grass in the summer and hay in the winter with added hard food to ensure that they have the vitamins and nutrients they need. They have only a bottom set of teeth at the front and hard top gums on which to tear the grass.

Liz now has six on her land, the descendants of Zebedee and Zachary living at nearby Abbotts View Farm. They are herd animals and get stressed if left on their own, even for a short amount of time, so most owners have at least three or more. In the wild, predators came from above so alpacas feel vulnerable if their top knot is touched, which is a shame because their soft furry head is always the most tempting place to stroke.

Zebras

There must be some eccentricity of spirit, or at the very least a highly creative mind, to think of harnessing three zebras and only one horse to a carriage. This is exactly what Walter, the 2nd Lord Rothschild, did.

Not everyone in the Rothschild family was interested in banking and collecting great works of art. Baron Ferdinand de Rothschild, who built Waddesdon Manor near

Above left: Literary Institution Club's stained-glass window.

Above right: Zebra. (By kind permission of the Zoological Society of London)

to Aylesbury, started an aviary in the grounds, which you can still see today. Other close relatives journeyed to East Africa to study giraffes and okapi, and one father and daughter became the leading experts on fleas and conservation. However, it was Walter who became the most famous naturalist with his exceptional collection, now on display at Tring Museum.

He also helped Aylesbury with an endless amount of donations and subscriptions to many charities. He provided a Literary Institute building in Temple Street, the Victoria Club in Kingsbury and public baths in Bourbon Street.

Apart from his charity work his real love lay in the natural history world. At a time when the popularity of professional and amateur naturalists was growing, Walter Rothschild outshone them all. He possessed the largest private collection of natural history specimens in the world and with his two curators they described over 5,000 new species and wrote 1,200 books and articles on the subject. Such was Walter Rothschild's reputation as an acclaimed zoologist that a number of species have been given the added name of *rothschildi* as a sign of respect to a man who dedicated his life logging and conserving new species – and, of course, training zebras to draw his carriage!

Bibliography

Hanley, Hugh, *Aylesbury – A History* (Chichester: Phillimore & Co. Ltd, 2009)

Lambert, Tim, various historical articles

Smith, Angela, *What Would Thomas Think?* and *Thank You – William Harding* (printed by ALMAR (Tring) Ltd)

Wilson, John Marius, *The Imperial Gazetteer of England and Wales* (Edinburgh: A. Fullarton & Co.)

www.aylesburytowncouncil.gov.uk

www.aylesburyvaledc.gov.uk

www.british-history.ac.uk

www.buckscc.gov.uk

www.buckscountymuseum.org

www.bucksresearch.co.uk

Acknowledgements

The author and publisher would like to thank the following people and organisations for permission to use copyright material in this book: Bucks County Museum, Jennifer Cooper, Adrian J. Fell, National Trust/Waddesdon Manor, Les Stocker/Tiggywinkles, and the Zoological Society of London.

Every attempt has been made to seek permission for copyright material used in this book. However, if we have inadvertently used copyright material without permission or acknowledgement we apologise and will make the necessary correction at the first opportunity.

I would also like to thank the following: Liz Barlow and Richard Waller for allowing me on their land to take photos and to learn more about the history of their livestock; Ken and Joy Wilkinson for the loan of his gazetteer and for the coffee and cakes, supplied, respectively; Glenn Moxley for his encouragement throughout; and Mark and Anna Moxley for their help with all things computer-related. Finally, my thanks to Wendy Turner for her aerial photo, her help, advice and encouragement, and with thanks to Ray Wilkinson for flying her over Aylesbury!

About the Author

Yvonne Moxley has an unquenchable thirst for history and has written a historical novel about Grace Darling and a children's book on the life of a gargoyle (not yet published). She began her writing life many decades ago working as a junior reporter for *The Christian* newspaper in London, followed by scriptwriting for two children's comics, *Pippin* and *Playland*. More recently she obtained an MA in Creative Writing at Brunel University and has been published in *Hertfordshire Life* magazine, *The Lady* website, Thompson's brochures, and has had a half-hour story recorded for Radio Four. Yvonne lives in Harpenden, has a beautiful summerhouse in which to write but prefers to stare at a blank wall in her study where she can focus on working rather than being lured into the garden.